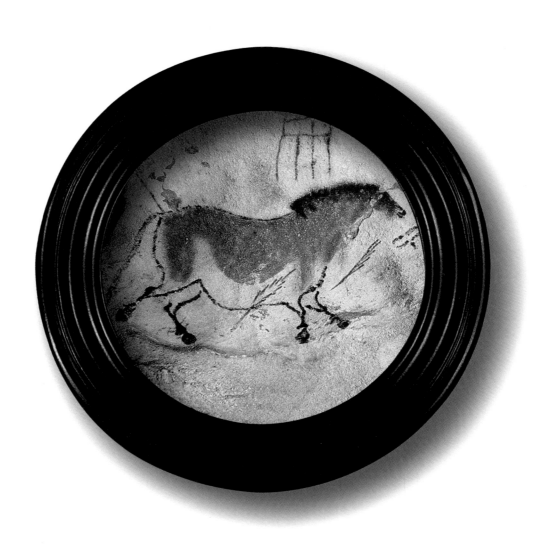

From Lascaux to Brooklyn

Paul Rand

Yale University Press
New Haven & London
1996

The following essays by Paul Rand are reprinted with the permission of the original publishers. Most have been updated and edited.

Typography: Style Is Not Substance
AIGA Journal, 1993

Object Lessons The New Criterion, 1993

Failure by Design New York Times, 1993

Designed by Paul Rand.

Grateful acknowledgment is made to the following for permission to reproduce illustrations on the following pages:

Alinari/Art Resource, NY 7, 11, 13–14

Bettmann Archive; *dust jacket and frontispiece*, 3, 154, 174

Kunsthistorisches Museum, Vienna 8, 9

Metropolitan Museum of Art, New York 33
Hsien-yü Shu, *Song of the Stone Drums*, dated 1301. Detail. Handscroll, ink on paper, 17⅞ x 143½ in. Bequest of John M. Crawford, Jr., 1988 (1989.363.29)

National Gallery of Art, Washington, D.C. 5
Paul Cézanne, *Still Life with Apples*, presented to the U.S. Government in memory of Charles A. Loeser, on loan to the National Gallery of Art, Washington, D.C.

Photo © Stanley K. Patz 54–55

Photo © David Todd 17, 21, 23, 34, 172

Henryk Tomaszewski, Warsaw 73

By courtesy of the Board of Trustees of the Victoria and Albert Museum 25

Printed by Mossberg & Company Inc.
Separations by PDR Royal.
Applied Graphics Technology, New York.
Cardinal Communications Group, New York.

L.C. 95- 61920. ISBN 0-300-06676-7

10 9 8 7 6 5 4 3 2 1

To all my friends and enemies

Perpetual modernness is the measure of merit in every work of art. *Ralph Waldo Emerson*

There is no such thing as bad content, only bad form. This explains the place of form in art. *with few exceptions

Contents :

Preface

The cave of Lascaux was discovered in September 1940 by four
boys roaming through the woods near Montignac in the
Dordogne (France). Among the many drawings of ibex, oxen,
bison, and antelope is the sophisticated drawing of a wild horse
(frontispiece), sometimes referred to as the Chinese horse
because it seems to have been transplanted from an old Chinese
print. Leroi-Gourhan's chronology for paleolithic art places
the images in the ancient Magdalenian period, circa 15,000 B.C.

The great lesson of the cave paintings of Lascaux is
that art is an intuitive, autonomous, and timeless activity and
works independently of the development of society.

The premise on which this book is based draws no distinction
between the so-called fine arts and the applied arts or artifacts.
Even the terms *art* and *design*, *artist* and *designer* are used
interchangeably. Unlike the practitioners of *l'art pour l'art*, I
believe what determines the status of art is not genre but quality.
Thus, a beautifully designed advertisement, poster, or piece
of printed ephemera, assuming that it is both utilitarian and aes-
thetically satisfying, is as much a part of the genus *art* as is a
painting or sculpture. In fact, as I see it, if a printed piece focuses
only on the aesthetic, ignoring the practical, it does not
qualify as art.

Like mathematics, the principles of aesthetics involve the
abstract formal properties of things and applies to everything —
to apples and to oranges, to ideas and to things — regardless
of one's feelings, opinions, or emotions.

It is naive to believe that one can explain in just a few words
what others have considered it a "formidable task" to define: the
complexities of the ineffable — of aesthetics — and the defini-
tions of art, form, design, intuition, and expression, as well as the
ramifications of communication. My purpose in writing this
book is to clarify problems that have always baffled me and to
emphasize the importance of the idea as such, as a unique
thought and as the very life of form. This book is not a compre-
hensive study of the philosophy of art. The ideas expressed
here are based on empirical practices, laced with whatever wis-
dom I can claim or quote.

I designed this book with the hope of arousing the reader's
curiosity, underlining the relevance of the study of aesthetics,
and linking art to daily work. The book is my attempt to define,
as best I can, aesthetics and the aesthetic experience as they

"I have not attempted the formidable
task of defining 'aesthetic' in general, but
have simply argued that since the
exercise, training, and development of
our powers of discriminating among
works of art are plainly aesthetic activities,
the aesthetic properties of a picture
include not only those found by looking at
it but also those that determine how
it is to be looked at."

Nelson Goodman,
"Art and Authenticity,"
Aesthetics Today
(New York, 1980), 193

X.

Albert Guérard,
"Dream,"
Bottle in the Sea
(Cambridge, 1954), 81

affect the designer, the student, the marketer, and the researcher and to help designers articulate some of their problems.

At the same time, it is well to remember that "a great poet or painter may hold the wrong theory, an array of conflicting theories, or no theory at all. Who cares? The work is the thing."

The practice of design—the art of communication—is sorely lacking a *means* of communication, a language to make the practice of and discussions about design clear and interesting. There are a number of important books about aesthetics. What they have in common is heft and complexity (Monroe Beardsley's book on aesthetics totals 614 pages, and Hegel's reaches 1,237 pages). While not easy reading, they are immensely rewarding.

I have formatted this book, at least the first section, as a primer. I believe this style is as suitable for adults as it is for children, for it promises less verbiage and a speedier route to the point. The eighteenth-century Bodoni typeface in which the book is set is an example of a basic design that never goes out of style and a reminder of Dewey's "a work of art is recreated every time it is esthetically experienced."

The remainder of the book deals with work—and problems—in progress and connects both to principles of aesthetics. Even though the subject matter of the various chapters may seem quite diverse, each bears a kinship to the cave paintings of Lascaux. Aesthetics is the common ingredient. *Corporate Decorum*, for example, is concerned with the relation between art and business. *Four Presentations* attempts to demonstrate how the subject of design can be presented to prospective clients. *Tschichold versus Bill* is a spirited and emotional debate about typographic style. And finally, *More about the Grid* is a graphic demonstration of the aesthetics of combinatorial geometry.

Thanks to Judy Metro, my editor, whose skills have not faded with the passage of time, and to Susan Laity, for her eagle eye; to Philip Mimaki, for his magical somersaults on the computer; to Gregory Corrigan, Doug Evans, Baruch Gorkin, Nick Juliani, John Maeda, Mario Rampone, and Mike Tardif, for their technological talents; and to Marion, my wife and walking Webster.

xi.

Q.

What
do the cave paintings
of Lascaux
have in common
with …

... The Tower of Pisa ?

A Romanesque campanile on the Arno, built in the twelfth century of white marble, 293 steps to the top. Its oblique orientation, for which it is famous, is 14 feet off the perpendicular.

Ironically, it is this very aberration that produces so dynamic a composition in relation to its surrounding buildings. But is it the formal composition, the relations between diagonal and vertical elements, or the perception of impending disaster that is so arresting ? The element of tension is no small factor when one first experiences this building.

The tower, a study in the harmony of heterogeneous elements — cylinders, semicircles, and oblongs — is also a study in negative and positive space, light and shade; in addition, it is a fine example of rhythmic animation, contrasting textures, and the hypnotic repetition of elegant arches — multiple miniatures of the leaning tower.

Max Raphael,
The Demands of Art
(Princeton, 1968), 215

"In the visual arts all content and forms depend on optical, tactile, and motor sensations — the first are dominant in painting, the second in sculpture, and the third in architecture." Like the paintings on the walls of the caves of Lascaux, the tower of Pisa evokes all three.

2.

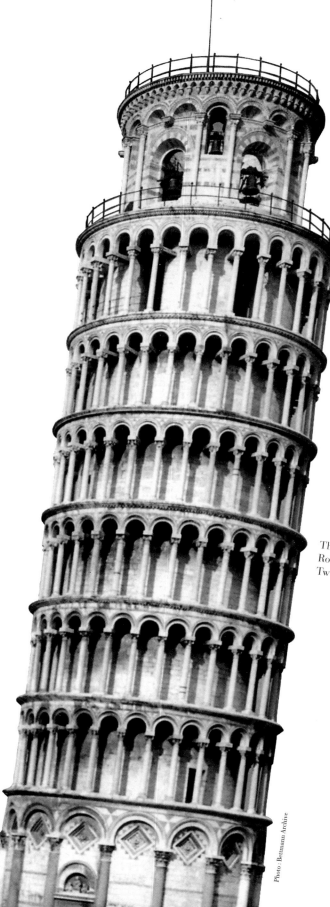

The Leaning Tower of Pisa
Romanesque style
Twelfth century

Question ...

… Cézanne's Apples ?

Cézanne's still life is not three apples poised on a white dish but the *effect* of three apples on the interested spectator. His brush strokes are formal means of pulsating contrasts.

The colors are not the subject's but the painter's; they are complementary effects, the vibrancy of paint, not the imitation of things. "One must not reproduce it," said Cézanne, "one must interpret it; by means of what? by means of plastic equivalents and color."

John Rewald,
Paul Cézanne
(New York, 1948), 180

Roger Fry,
The Artist and Psychoanalysis
(London, 1914), 6

"No one who has a real understanding of the art of painting," said Roger Fry, "attaches any importance to what we call the subject of a picture — *what* is represented. To one who feels the language of pictorial form, all depends on *how* it is represented, nothing on *what*. Cézanne, who most of us believe to be the greatest artist of modern times, expressed some of his grandest conceptions in pictures of fruit and crockery on a common kitchen table."

Fry's statement about form is as applicable to the paintings of Lascaux as it is to Cézanne's apples. The lasting intrigue of the cave paintings is due not only to *what* they depict but to their astonishing skill and arrangement.

4.

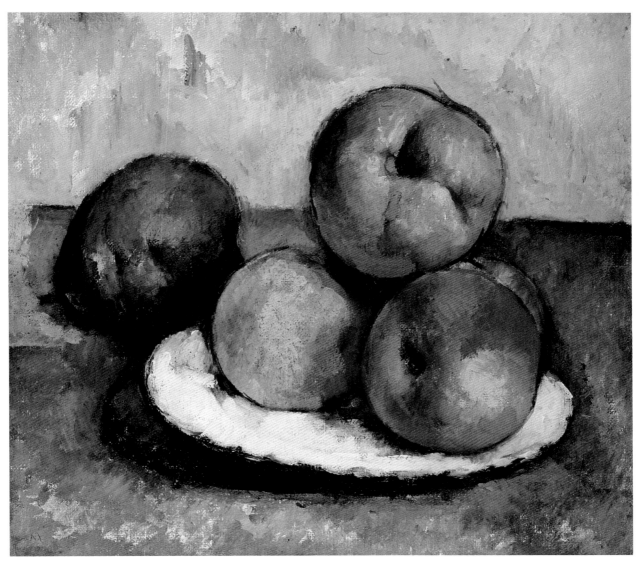

Paul Cézanne
Still Life with Apples
National Gallery of Art, Washington, D.C.
Charles A. Loeser

5.

... The Baptistery of Florence ?

One enters the baptistery through
what Michelangelo called "the gates of
paradise," the bronze panels designed by
Lorenzo Ghiberti that were the product
of a competition won by him and Filippo
Brunelleschi.
The building sits serenely in the center
of a bustling city, close to Brunelleschi's
dome for the cathedral of Santa Maria
del Fiore and Giotto's campanile.

Simple geometric shapes —
rectangles, squares, diamonds, and half
circles of dark green marble —
embellish every surface, a Euclidian
inventory of abstract images.
The structure, an octagon covered by
a pyramidal roof, with each facet
enveloped by three dramatic arches, is a
model of the geometer's art.

One quickly realizes that simplicity
and geometry are the language of time-
lessness and universality.

But it is the toylike quality of the bap-
tistery that is so startling.
It seems coincidental that the building
in which Dante was baptized, and which
is still used to baptize the children of
Florence, should underscore
Baudelaire's notion that the toy is the
child's first initiation into art.

The joyous decorations that embellish
the Church of St. Basil in the Kremlin, although
much more exuberant, are reminiscent
in their spirit of the Baptistery in Florence.
Le Corbusier called the cathedral "a whole
revelation in the sphere of art."

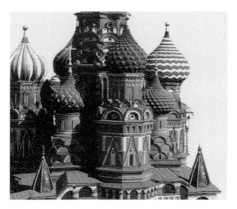

Charles Baudelaire,
"The Philosophy of Toys"
in *Essays on Dolls*
(London, 1994), 18

6.

Photo: Alinari

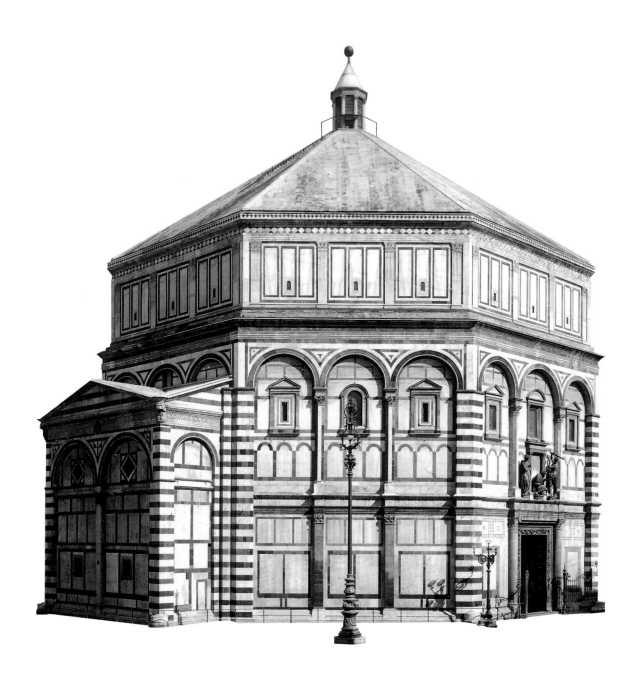

7.

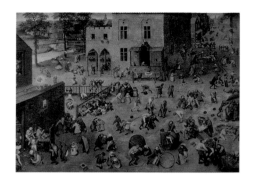

... Brueghel's *Children's Games* ?

It is no revelation that economic, social, and political awareness played a pivotal role in the art of Pieter Brueghel. One wonders if a present-day visitor to the Kunsthistorisches Museum in Vienna could ever see Brueghel's painting the way a Flemish burgher would have seen it.
But as with the work of all great artists, the language of morality and social awareness is expressed in a language of form that endures.

The texture of Brueghel's pictures is a complexity of contrasts, movements, and expressions united in a symphony of light and shade, curves, angles, and emotions — the whole gamut of conflicting phenomena.
In Brueghel's *Children's Games*, sturdy buildings serve as visual backdrops for frolicking kids; the passive and the active, simplicity and complexity are in harmony.
Each compact and stocky little figure seems to have been patiently whittled out of some magic substance.
And each game, though clearly articulated, seems somehow to be part of one giant ensemble of fun and frolic.

In the end one experiences the collective joy of children, colors, and forms at play.

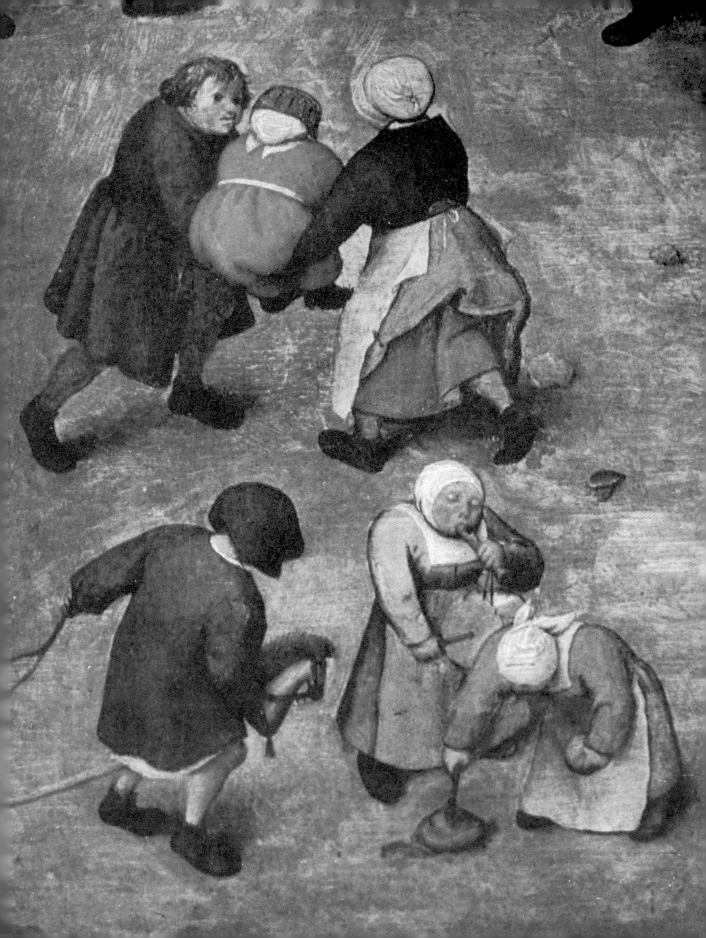

... Romanesque Capitals ?

These capitals, where ornaments,
animal, and rider are treated as isolated
fragments in an imaginary space, share
a kinship with children's art.

To the illiterate the capitals were
and are the living text of the Bible — an
ageless art that appeals to all ages.

"I learned from poetry that art is best
derived from artless things."
This is what one senses experiencing
Romanesque art.

The same universal qualities of
naïveté and simplicity that characterize
the work of all primitive cultures are
inherent in this art.
Even the means of expression by
the great painters of our time is related
to Romanesque art.

Jimmy Carter,
Always a Reckoning
(Times Books, 1995)

Fernand Léger
Pen and ink drawing, 1944
Author's collection

Léger's equalization of animate
and inanimate things in this pen and ink
drawing is equivalent to the way horse,
rider, and surrounding ornaments
cohere on the Dintorni capital.

Photo: Alinari

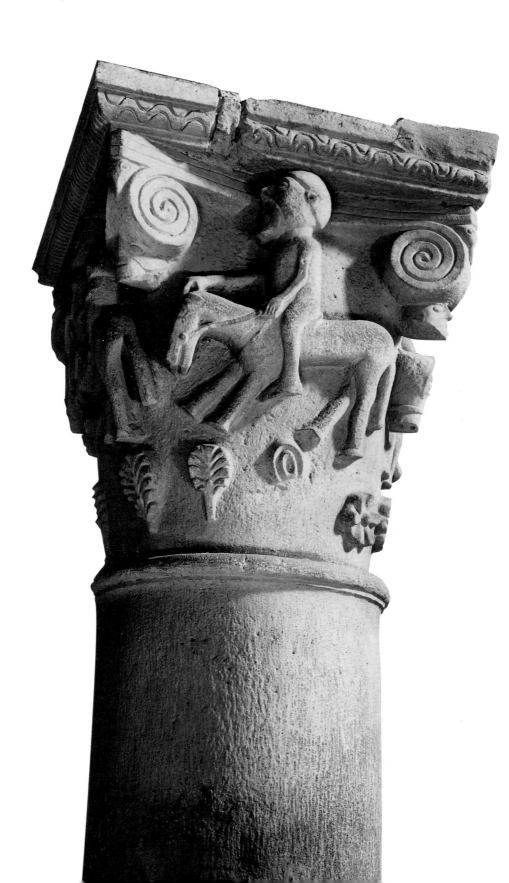

II.

Question ...

The Fountains of the Lions
Twelfth to fifteenth century
Grenada

... The Fountains of the Alhambra ?

Geometry, which has always played
a significant role in Muslim art,
permeates the design of the Patio de los
Leones in Grenada, from its twelve
silent lion sentinels to its dodecahedron
base and basin.

The highly simplified, delicately
carved lion details contrast dramatically
with the elaborate arches in the back-
ground.

The richness of ornamentation in the
whole complex, the abundance and vari-
ety of tile configurations, the orientation
and flow from room to room, area
to area, provide a unique architectural
experience.

Even water was considered a sculptural
element; it hangs as if frozen in mid-air.
The toylike stylization (similar to
the Indian tiger on page 25) and simplifi-
cation of the twelve lions hint at
a more than cursory understanding of
formal relations among the different
components.

The Patio de los Leones, an ode
to the geometer's art, was also the last
achievement of Muslim art in the
Iberian peninsula.

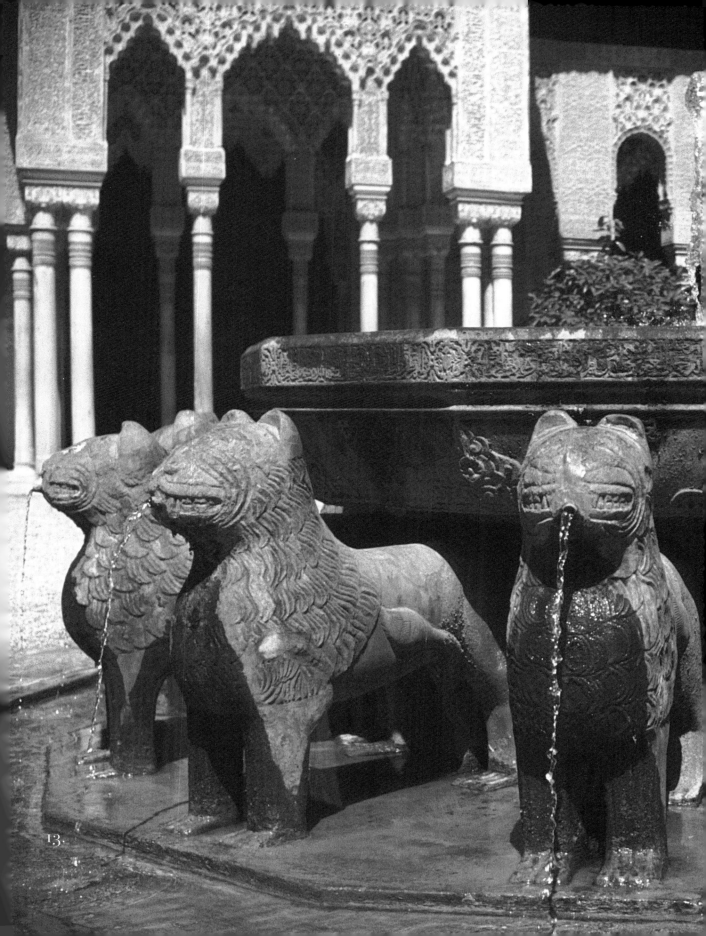

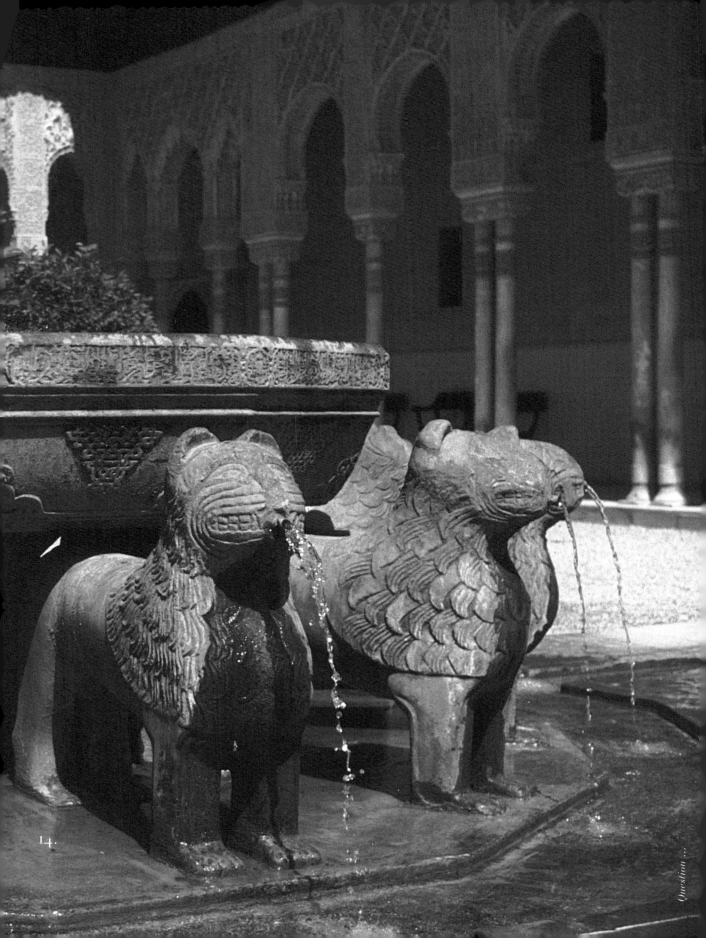

14.

... The Parthenon ?

Ictinus, the architect of the Parthenon,
was not the only practitioner who
applied the principles of Greek geometry
to his structures.
Yet the magnificence of the Parthenon
outshines similar buildings of the
period.

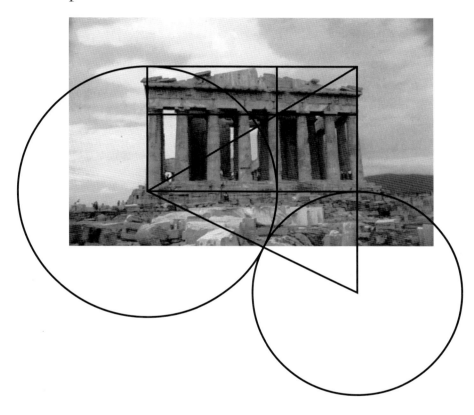

Diagram shows one
of many constructions of the
golden section (1.618)
constructed on a right-angle triangle
and two contiguous circles.

The beauty of any artifact cannot be
attributed solely to its proportions.

What a particular proportion
contains, and how it is designed, are
more important than the shape
of its containment.
Proportional systems are an incentive
for some, an inspiration for others,
and a crutch for too many.

Question ...

... African Sculpture ?

The exaggerated body and facial
features of this sculpture are typical of
the art of African sculpture.
Furthermore, the artist managed to
preserve the spontaneity, imagination,
and unselfconscious vision of the
child's world.
Its creator understands that emotions
can best be expressed visually by
overstatement rather than by literal
depiction.

Was what attracted Picasso, Braque,
and others to African art not what it
stood for but what it looked like, its
form, much more than its mysterious
content ? Is this the same impulse that
motivates us to adorn our walls with
African art ?

Samuel Taylor Coleridge,
in John Dewey,
Art as Experience
(New York, 1934), 194

"Every work of art," said Coleridge,
"must have about it something not
understood to obtain its full effect."

African art played more than a passing
role in the art of cubism.
Freedom of expression, simplicity,
imagination, fantasy, spontaneity, and
innocence were part of its formal
language.
What was ritual and symbolism
to one was invention and formalism to
the other.

16.

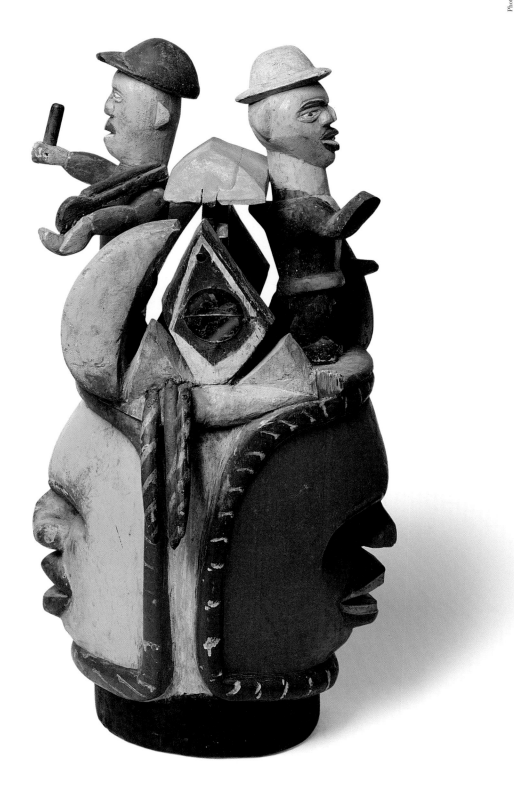

Katsura Palace
Fifteenth century
Kyoto

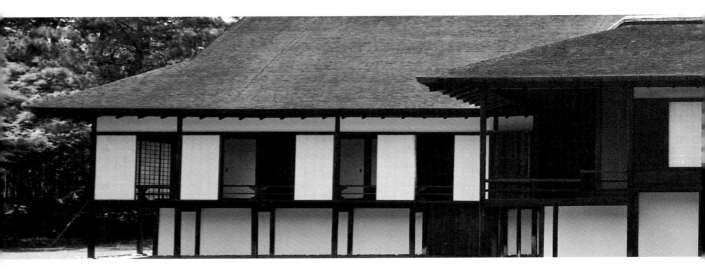

Serenity and order crown the splendor
of this enchanted summer palace.
Coleridge's unity in variety is everywhere.
To experience Katsura is to experience
perfection …

The variety of patterns made possible
simply by moving the *shoji* (rice-paper
screens) is endless — a tribute to the
architect's sensitivity and the craftsman's
ingenuity.

Here, "form followed function"
long before Horatio Greenough and
Louis Sullivan voiced their beliefs.
Mondrian's aesthetics were there long
before Mondrian.

18.

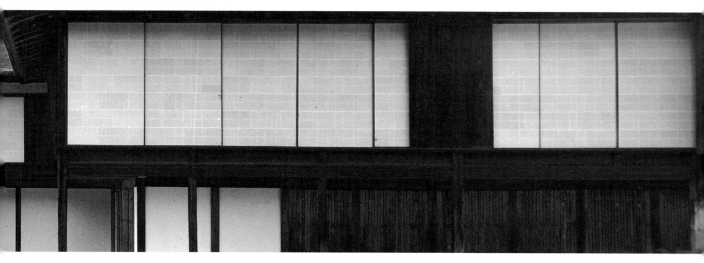

Master of yin and yang, Katsura Palace
is a skillful integration of contrasts
and rhythms : horizontal facades, vertical
posts, diagonal roofs ; dark and light,
long and short, wet and dry ; water,
stones, grass, wood, and paper — a haven
of tranquillity and beauty.

The poetry of Zen is embodied in the gar-
dens and architecture of Katsura.
The wild horse of Lascaux, also called the
Chinese horse, evokes this Zen-like
quality as well.

… A Fisherman's Buoy?

Modest subject matter, modest means, and modest talent do not always prevent an artifact from offering an aesthetic experience to the viewer.

These buoys, clearly the product of loving hands, are made by fishermen or craftsmen who know their job.
Their colors, arbitrary or not, may have come from paint cans lying around a boat yard.
It is the effect that matters.

The arrangement and juxtaposition of objects is not accidental ; in fact, it is the contrast of the casual and the careful that is meaningful in the end.

That this marine still life may be reminiscent of Giorgio Morandi's contemplative, yet disarmingly simple compositions is coincidental but not surprising.
What they share are the virtues of economy, simplicity, and modesty of means.

This is a useful object lesson for designers who believe that mundane subject matter, like soap or soup, is a hindrance to creativity.

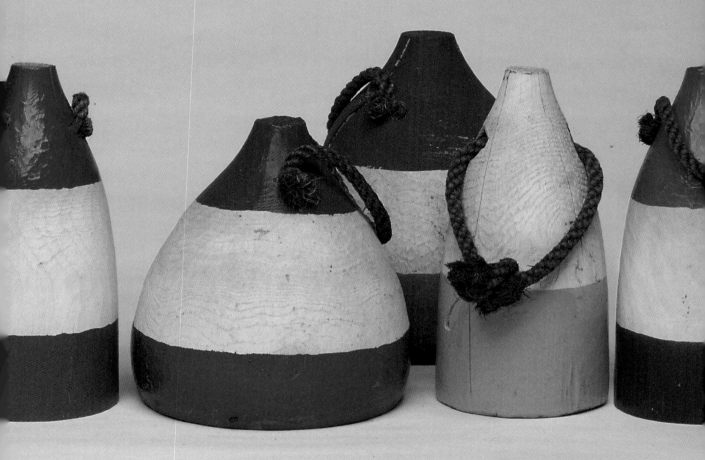

21.

Gorgan pitcher
Twelfth to thirteenth century
Author's collection

... A Gorgan Pitcher ?

The decor of this Gorgan pitcher defines
its personality ; sensitivity, subtlety, and
simplicity determine its form.

The swelling blue stripes embellishing
the belly of the vessel accentuate
its profile and, like blue veins, impart life
to an otherwise lifeless object.

Decoration, often given a pejorative gloss,
is the essence of this object.
Without decoration, the pitcher would
appear less interesting, almost naked, to
the viewer.

Form fixes the appearance of things,
what things look like.
Matter is what it shares with other
objects.

Grace, dignity, passion, and pleasure
signal the presence and suffuse the
atmosphere of anything worthy of the
accolade *art* : a persuasive poster,
a painting, an elegant room, a Gothic
cathedral, or a simple utensil.

Max Raphael,
The Demands of Art
(Princeton, 1968), xxii

"Art changes our whole attitude to
life, not merely our understanding of it
but also our evaluation of it, in fact,
all our perspective."

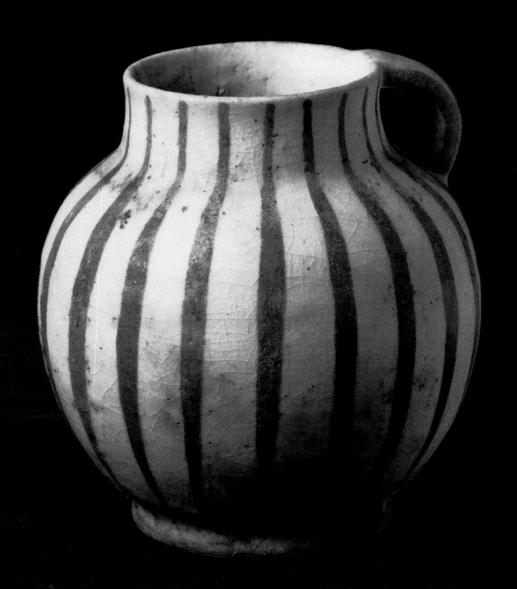

... Tipu's Tiger ?

This wooden effigy, a kind of non-musical hurdy-gurdy that simulates the growls of a tiger and the cries of his victim, is at first disturbing.
But its expression and scale are so toylike, its color so brilliant, that the impression is merely startling.

A tragic event treated in a lighthearted manner combines to create the humorous effect of this giant (about one meter long) toy.

The gold-leaf pattern that embellishes the animal's body is an ingenious evocation of the tiger's natural habitat. The delicate handling of the decoration and the fanciful form of the tiger make a dramatic foil to the deadly nature of the occasion depicted.

This is an interesting example of form mollifying content.

The spirit that permeates this sculpture is similar to that which is evoked by the fountain of lions on pages 13 and 14, a quality it shares with objects designed to entertain.

Tipu's Tiger
Presented to the Sultan of Mysore
in the 1790s
Victoria & Albert Museum
London

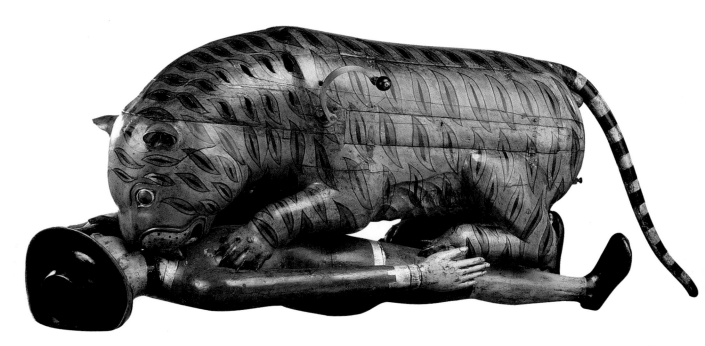

25.

The cactus photograph was
not subjected to manipulations other
than cropping and silhouetting.
The process by which a photograph
may be transformed is almost endless:
composing, simplifying, rearranging,
enlarging, reducing, distorting,
fading, blurring, cropping, focusing,
fragmenting, repeating, overlapping,
isolating, accentuating, solarizing
juxtaposing, exaggerating, overexpos-
ing, underexposing...

Walker Evans,
in Hound and Horn,
Eugene Atget
(New York, 1931)

… A Photograph of Nature ?

A work of art is a dialogue, a
picture filtered through the mind and then
transformed.
Lyrical understanding of the subject,
trained observation, special feeling for
patina, an eye for revealing detail,
and poetic content comprise what Walker
Evans describes as the photographer's
magic.

A work of nature is not a work of art.
Hegel referred to natural beauty as "the
prose of the world."
The photo of this cactus is artistic only to
the extent that the photographer
has selected and interpreted the subject.

The quality of a picture is measured
not by how much it adheres to nature but
by how far it departs from it.

When one encounters a beautiful
landscape, suggested André Malraux, one
is possibly experiencing that
landscape as the work of a great painter
like Constable, or Monet, or …

G.W. F. Hegel,
"The Range of Aesthetic Defined,"
Introductory Lecture on Aesthetics
(London, 1993), 4

"Artistic beauty stands higher than
nature, for the beauty of art is beauty that
is born — born again, that is — of the
mind, and by as much as the mind and its
products are higher than nature and its
appearances, by so much is the beauty of
art higher than the beauty of nature."

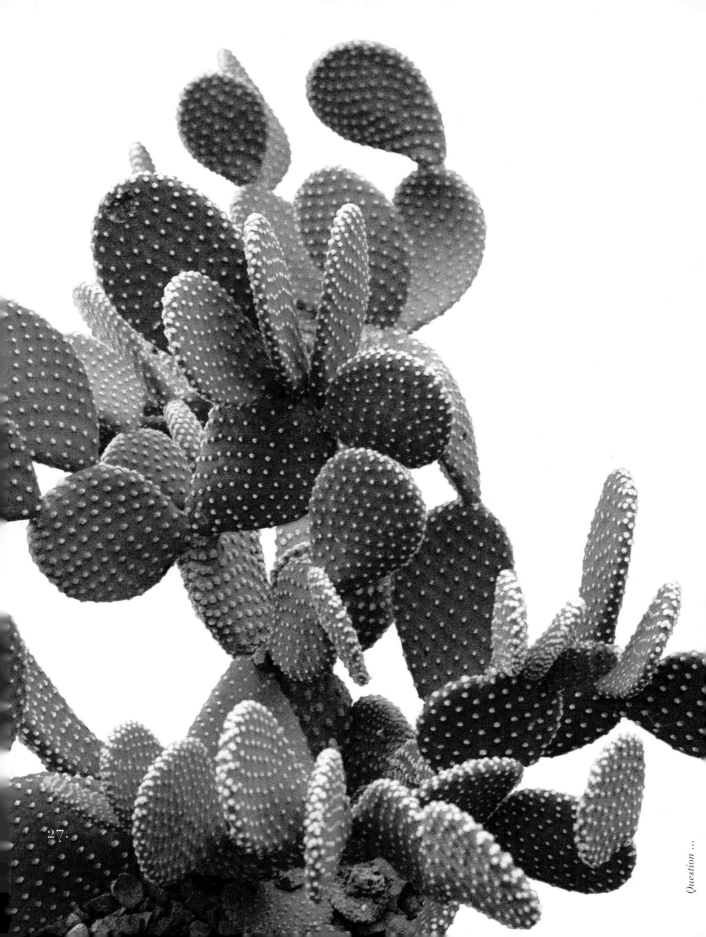

27.

A. The cave paintings of Lascaux, as well as the exhibits on pages 3 to 27, are objects of *aesthetic experience*, irrespective of time, place, purpose, style, or genre.

Aesthetics is concerned with the laws of perception, not with the fleeting aspects of style or taste. It is one of the three disciplines : logic, ethics, and aesthetics (the so-called normative sciences). The subject of aesthetics is so convoluted that it cannot possibly be pinned down to a simple definition.

"In the original Greek derivation the term aesthetics denoted the study of sense experience generally, and it was not until the mid-18th century, following a usage introduced by the German philosopher A. G. Baumgarten (1714-62), that particular reference to the idea of beauty in nature and art was established. Baumgarten is best known for his long, unfinished treatise, *Aesthetica*, whose principal claims are that art is founded upon mental representations that are both sensuous and bound up with feelings, and that in this respect beauty is not a simple and distinct intellectual idea but an elaborate and confused complex."

A Dictionary of Philosophy
(London, 1979), 6

Herbert Read,
Modern Art and Modernism
(London, 1982), 24

Aesthetics is the standard by which a work of art is judged.
It is essentially the study of the successive or simultaneous interaction of form and content.
How skillfully these components are fused will determine the aesthetic quality of the work in question.

There are two parts to this hypothesis. One relates to the artist, who, unlike the spectator, is intensely involved — intuitively, emotionally, and perceptually; the other, to the object, which possesses a plastic unity that differentiates it from the ordinary artifact.

"It is at least arguable that the purely formal element in art does not change; that the same canons of harmony and proportion are present in primitive art, in Greek art, in Gothic art, in Renaissance art, and in the art [and design, traditional or trivial] of the present day."

To this one may add the canons of: order, unity, variety, contrast, grace, symmetry, asymmetry, rhythm, rhyme, regularity, movement, interval, coherence, dissonance, balance, tension, space, scale, weight, texture, line, mass, shape, light, shade, color, ad infinitum. These are among the *tools of form—by design, by chance, by improvisation.*

The endless conflicts between the spiritual and material, between ends and means, form and content, form and function, form and facture, form and purpose, form and meaning, form and idea, form and expression, form and illusion, form and habit, form and skill, form and style need to be resolved.

It is the merging of these conflicts that determines the aesthetic quality of a painting, a design, a building, a sculpture, or a printed piece.

A work of art, then, is the resolution of conflicting relations.
It is a unity of opposites, a series of steps reflecting Hegel's dialectics : *thesis*, the subject ; *antithesis*, the conflict ; and *synthesis*, the resolution.

Whatever one's beliefs, art is commentary, art is revelation, art is the culmination of the creative process.
It is a by-product, not a goal, a point of view about a particular object that rises above its topical source.
It is not just a facsimile but an opinion expressed visually in a distinctive way.

Art is reality enhanced.

31.

Answer ...

Hsien-yü Shu
Song of the Stone Drums, 1301 (detail)
in Wen C. Fong,
Beyond Representation
(New Haven, 1992), 418, pl. 97

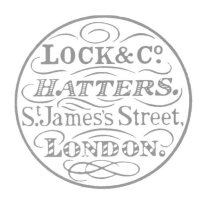

Intrinsic quality, not age, determines
the real value of a work of art.
The wild horse of Lascaux is a work of
art not because it has survived seventeen
thousand years but because, like the
calligraphy of Hsien-yü Shu, it is a work
of beauty, spontaneity, and skill.

Not quite as old as Hsien-yü Shu
calligraphy, the perhaps two-hundred-
year-old label for Lock & Company
embodies many suggestive ingredients
of age and integrity.
The curlicues, arabesques, and
ornamental letters create an intricacy
and busyness that spell authority.
However, unlike one's reaction to the
calligraphy, on perusing the Lock label
one is aware of style more than
sensibility, which leaves one with the
impression less of a work of art than of
an artifice.

Good design is never old-fashioned or
dated, nor, in its presence, is one imme-
diately aware of a particular style.
By its very nature a work of art hides its
wrinkles by constantly renewing itself.
The term *old-fashioned* is an expres-
sion of sentimentality and nostalgia, both
of which tend to distort one's under-
standing.
Sentimentality provides only a
momentary response to a work of art;
nostalgia provides a momentary escape
from reality.

草書

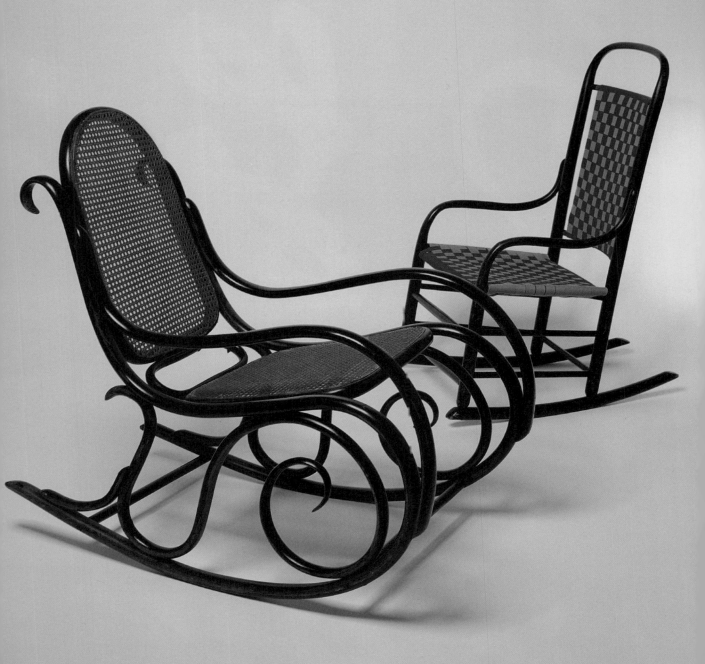

A work of art elicits unsuspected
associations and defines vague bound-
aries — it does not particularize,
it generalizes.

Well-designed objects are soul mates.
They seem always to go together; their
compatibility depends not on any
distinctive style or age or value but on
their intrinsic aesthetic qualities.

A Corbusier lounge chair can be at home
in almost any surroundings.
An African sculpture may adorn and
be in harmony with a style of
decoration it was never intended to
accommodate.

A nineteenth-century Thonet rocker
made in Vienna, for example, is
compatible with an eighteenth-century
Shaker rocker made in New Lebanon.
Like the wild horse of Lascaux, they are
old but not *old-fashioned*.

The Shakers were ascetics, as were the
constructivists, the suprematists,
the artists of the Bauhaus, Mondrian,
Van Doesburg, and others.
All these people shared principles of
economy and a reverence for materials.
Religion was for the Shakers what
aesthetics was for the artist.
What they also shared was sensitivity,
talent, and a sense of discipline.

35·

Answer …

Aesthetic experiences are intermingled
with past encounters.
The easel painter or the house painter
sees what his experience compels or
impels him to see.

Design decisions are often arbitrary.
Some designers, for example,
avoid antiques simply because they are
old, while others will cling to them
for their symbolic values.
Seeing the new in the old is one aspect
of innovation and a rich source of ideas.

Traditional roman numerals, for
example, offer some dynamic possibili-
ties for the creative mill.

Because they form a link to tradition
and are not absorbed casually,
they lend authority and cachet to writ-
ten documents.

In the visual pun at right the figure
8 stands both for itself and the letter *g*; it
is a kind of game, related to the rebus,
a puzzle composed of words that appear
as pictures.

By reading vertically, the abstract
aspect of the letterforms is dramatized,
thus making for a more interesting
and mysterious image.
This is a case in which readability was
not the prime factor.

37.

38.

Remember **6 Million Jewish Martyrs** April 18, 1993, Holocaust

Photo : Stanley K. Patz Retouching : Bob Bishop

Remembrance Day 50 Years of the Warsaw Ghetto Uprising

Answer …

Harold Bloom,
The American Religion
(New York, 1992), 27

"Without the aesthetic, we are not reading a poem, play, story, or a novel but something else."

Without the aesthetic, design is either the humdrum repetition of familiar clichés or a wild scramble for novelty. Without the aesthetic, the computer is but a mindless speed machine, producing effects without substance, form without relevant content, or content without meaningful form.

Expressions such as *computer art* and *creative tool*, either because they are misunderstood or because they are misapplied, are expressions of deception.

Max Raphael,
The Demands of Art
(Princeton, 1968), 184

"It is not technology as such that obstructs and weakens the artist's creative powers, but the circumstance that society fails to control technology and is instead controlled by it.... Unintelligent use of technology and its products brings an imbalance to the historical life of society and creates a conflict between the living and the dead, progressive and reactionary forces. As a result, centrifugal forces gain strength over forces of cohesion, and man's will to shape the world is paralyzed."

Today, the designer must understand the relation between aesthetics (the designer's raison d'être) and the computer (often his livelihood).

Each is a full-time occupation and each
a perplexing problem.
The computer provides answers, but
what are the questions ?

"Production has replaced design as the
central activity of people in this field,"
notes a friend, echoing a biographer of
William Morris, who said:
"Technological advance has made
ordinary skill and modest pride in work
redundant."
And Max Frisch put it this way:
"Technology is the knack of so arranging
the world that we do not experience it."

Production problems are not aesthetic
problems.
Production is the expediter, the
process by which aesthetic solutions are
put on paper.

By understanding this relation
one can avoid the pitfalls of misguided
or willful design and fix the place
of the machine as a tool for meaningful
design.

The conflict between design and tech-
nology, like the conflict between
form and content, is not an either/or
problem, it is one of synthesis.

Milton Glaser,
Graphics USA (February 1995)

Fiona MacCarthy,
William Morris, A Life of Our Time
(London, 1994), vii

Max Frisch,
in Rollo May,
The Cry for Myth
(New York, 1995), 57

Answer ...

H. W. Fowler,
"Novelty Hunting,"
*Fowler's Dictionary of Modern
English Usage, Second Edition*
(Oxford, 1965), 400

"When there's nothing new in
what I have to say, I must make up for its
staleness by something new in the way
I say it.
And if that were all, if each
novelty hunter struck out a line for him-
self, we could be content to register
novelty-hunting as a useful outward sign
of inward dullness, and leave such
writers carefully alone.
Unluckily they hunt in packs, and
when one of them has a find they are all
in full cry after it, till it becomes a
vogue word to the great detriment of
the language."

The *Accent* logo is a combined form
of the software's company name
and a collection of business-related flags;
together they form the letter A.

It is a rare coincidence for a name
and a symbol to have such a felicitous
relation.
But the designer has to discover
that relation before the design can be
realized.

The confluence of form and idea can be
attributed to a fluke, or a bit of luck.
The answer is always obvious once it is
pointed out.

Logo design
Accent Software International
Jerusalem, 1994

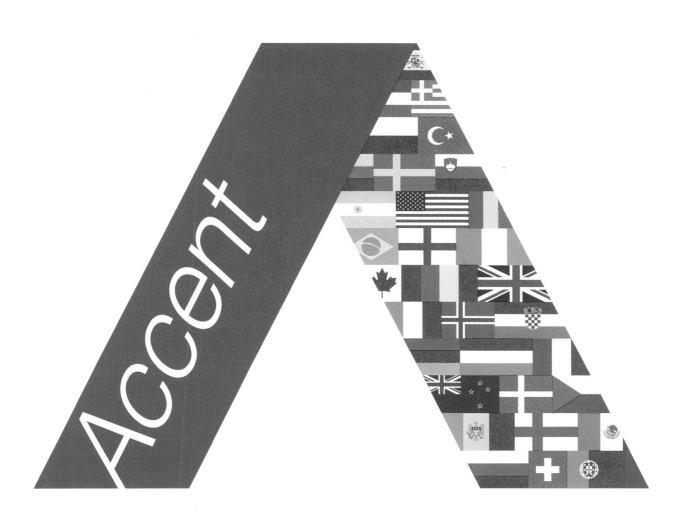

43.

Answer ...

Ideas, or the Life of Form

Ideas are fuel for the imagination; they
are the unique response to a meaningful
question.
Where do ideas come from?

Rudyard Kipling,
"The Elephant's Child,"
Just-So-Stories, stanza 1

"I keep six honest serving-men, they taught
me all I knew, their names are what
and why and when and how and where
and who."

Graham Wallas,
The Art of Thought
(New York, 1926), 93

There are four stages in the creative
process: 1. *preparation*, during which a prob-
lem is investigated; 2. *incubation*,
during which conscious thought is useless;
3. *revelation*, which yields the "happy idea";
and 4. *verification*, which embodies working
out an application of the idea.
This procedure, based on the ideas of
nineteenth-century physicist Hermann von
Helmholtz, comprises three typical stages:
saturation, *incubation*, and *illumination*.

John Dewey,
Art as Experience
(New York, 1934), 70, 199

Spontaneity plays a significant role:
"The spontaneous in art is the complete absorp-
tion of subject matter that is fresh, the
freshness of which holds and sustains emotion.
Staleness of matter and obtrusion of
calculation are the two enemies of spontane-
ity of expression."

We are also reminded that ends and means
must coalesce.
"Sensitivity to a medium as a medium
is the very heart of all artistic creation and
esthetic perception."

Logo design
Computer Impressions
New York, 1995

*The CI logo is similar
conceptually to the Gentry
design on page 47, except that it
also accommodates the
company name as an integral
part of the logo.*

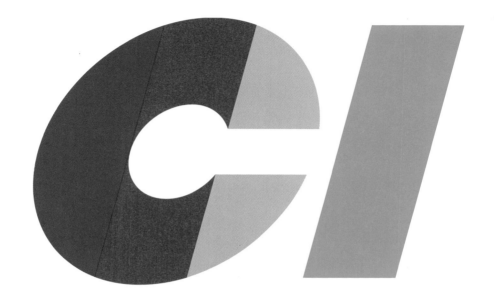

com-
puter

im-
press-
ions

45.

Ideas, or the Life of Form

Among a designer's most challenging
tasks is the creation of a logo.
Although it entails endless trial and
error and involvement with the vagaries
of research and marketing techniques,
it is a kind of problem that can result in
something so fresh, yet obvious, that
the only response is, "Why didn't I think
of that?"
A logo is the distillation of the complex,
the absence of the irrelevant.
It is the visual essence of simplicity.

The "G" design at right for a silk-screen
company uses its signature to display
its skills.
The playfully distorted, multicolored
logo is designed to pique the spectator's
curiosity and to suggest the nature of
the business.

The design not only depends on a
play of contrasting colors but uses circles
of different sizes, sinuous curves,
and unorthodox proportions to achieve
its effects.
The result is a design that is amusing,
easy to remember, and adaptable.

G.W. F. Hegel,
Introductory Lectures on Aesthetics
(London, 1993). 76

"The content of art is the idea,
and its form lies in the plastic use of
images accessible to sense."

46.

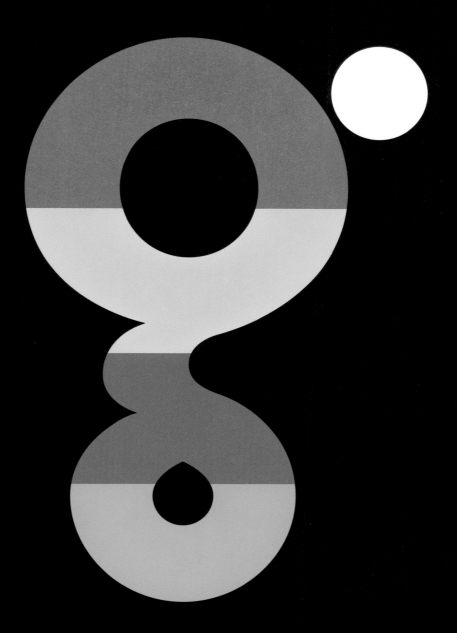

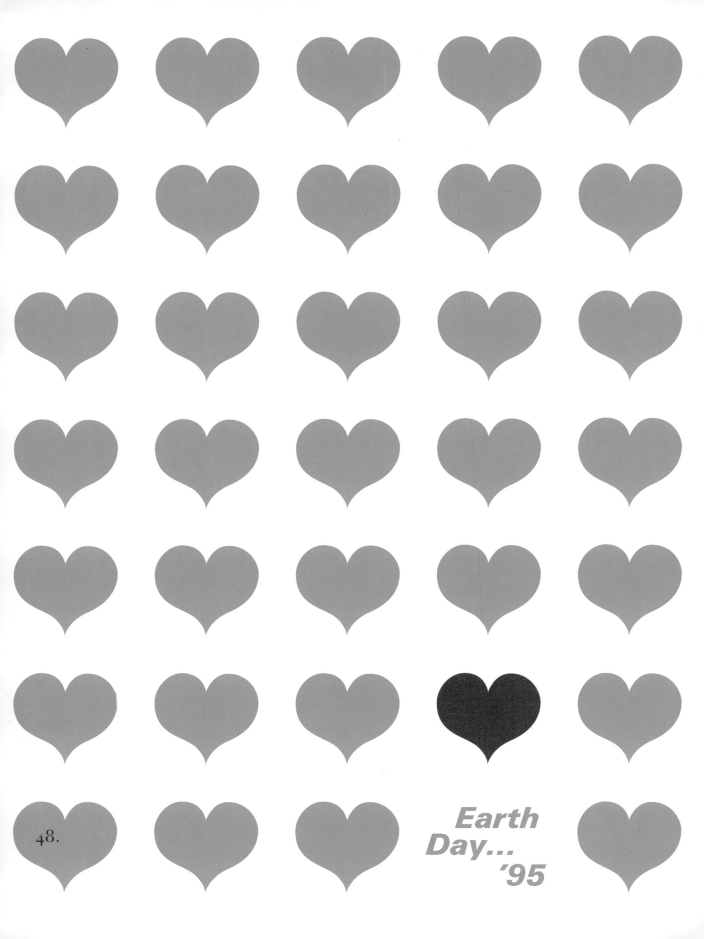

48.

Earth
Day...
'95

The formal elements that constitute the Earth Day poster at left are repetition, regularity, contrasting colors, and the psychological element of surprise.

Most environmental posters attempt to convey a positive message using negative means (see page 51). This poster, on the other hand, projects the positive image of hearts, but in an unexpected guise.

The ubiquitous heart symbol is resuscitated, so to speak, by pumping green into it.

The solution to a problem is inherent in the problem itself — *a game of hide-and-seek*.

When Picasso said, "I do not seek, I find," he was talking about ideas. But who was it who said, "Art is an idea that has found its perfect form"?

The role of the imagination is to create new meanings and to discover connections that, even if obvious, seem to escape detection. Imagination begins with intuition, not intellect. Like the artist's role, even the act of appreciation is imaginative. Imagination operates in the real world and not in a never-never-land.

The products of originality, very often, have less to do with invention than with interpretation — with seeing things in a way that is unexpected.

"Knowledge is power," said Hobbes; "Imagination is more powerful," was Einstein's rejoinder.

Things that sometimes appear original often turn out to be meaningless, for they depend on visual devices that appeal to those interested only in novelty or in formalist ideas, which correspond to fashion rather than to real need.

The ecology poster at right gives the spectator a choice between life and death.

50.

C H

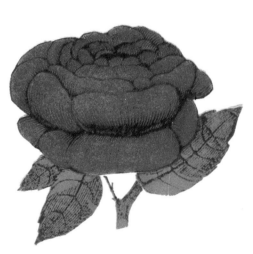 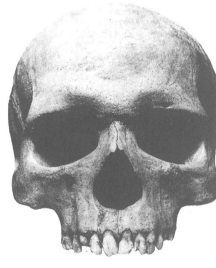 S

E

Unlike the poster on page 48, it depends on shock value for its effectiveness.

It demonstrates how ideas about the environment can be made more intriguing merely by forgoing ordinary narrative illustrations for the juxtaposition of seemingly unrelated images. Photomontage, which is the method used in executing this poster, offers infinite possibilities.

For example, the rose and skull, visual puns for the two missing *o*'s, are riddles designed to engage the reader.

Photomontage can say *much* more than the proverbial thousand words. Among the great inventions of the twentieth century, and still in its swaddling clothes, photomontage provides opportunities that have yet to be fully exploited.

Photomontage is illustration by association, by juxtaposition, by subtlety. It collapses time and pulls extraneous elements together — an ideal instrument for storytelling and for the visualization of complex ideas.

Direction Magazine (1935-1945) was
a self-supporting, one-woman operation:
Marguerite Tjader Harris was propri-
etor, publisher, and editor.
A sophisticated traveler, she was
able to meet, befriend, and cajole distin-
guished personalities to write for her
and support her ideas:
Theodore Dreiser, Le Corbusier, Julius
Meier Graefe, and many others were
among those who provided material for
the magazine — a politically oriented,
anti-fascist publication.

In 1938, at the age of 24, I was asked to
do one of the covers on a pro-bono basis.
Eventually, I was bartering my work for
Le Corbusier's watercolors.
This turned out to be more than ample
payment for my efforts.

These covers, beginning on page 55,
were designed between 1938, the time of
the invasion of Czechoslovakia, and the
end of World War II.
It was a time of turmoil not only on
the world order but also in the world of
art, with modernism on the upswing.

The designs reflect the influence of
the isms, and they are also concurrent
visualizations of war, upheaval, and
ultimate victory.

In one of the early issues, Le Corbusier's
When the Cathedrals Were White
appeared for the first time in the English
language.

The reward for pro bono is not always
just in heaven. Pro-bono designs do not have
to undergo the rigors of marketing and
research. And pro-bono jobs are generally
more interesting and challenging than
run-of-the-mill business assignments, which
are often driven by time-worn traditions
and prejudices.

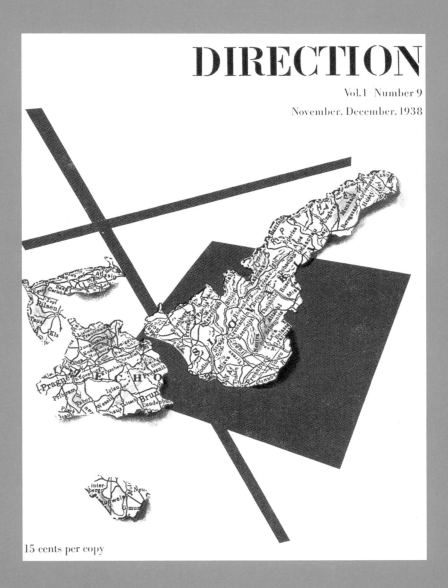

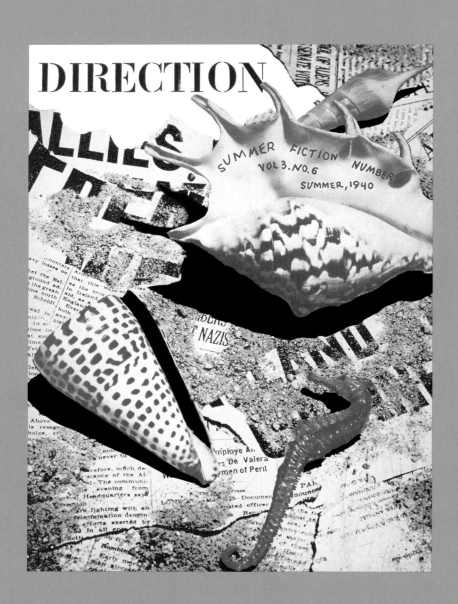

There were many articles of a similarly pioneering nature dealing with artistic, social, and political issues by critics, cartoonists, artists, and writers of great distinction around the world.

William Gropper, the American social satirist, was featured in many of its pages.

It takes more than luck, good ideas, and goodwill to accomplish meaningful — let alone distinguished — work. A receptive and intuitive patron, who understands the ways and wiles of the creative creature, is indispensable; Maggie Harris was certainly that.

57.

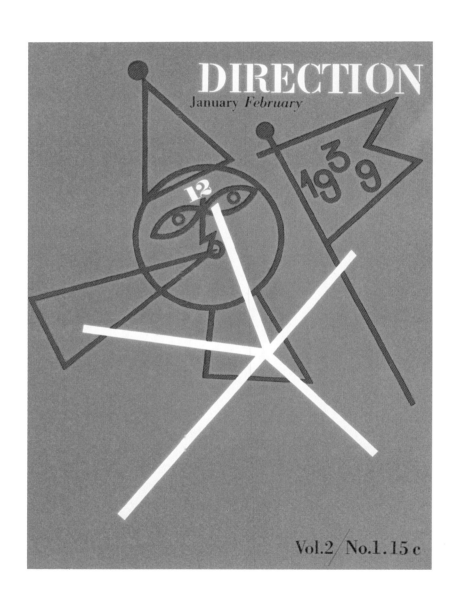

58.

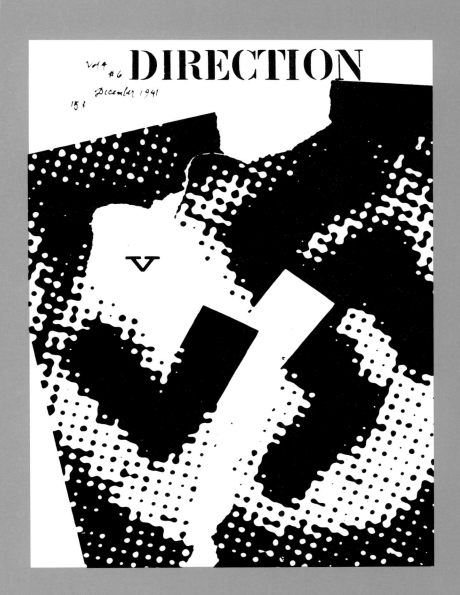

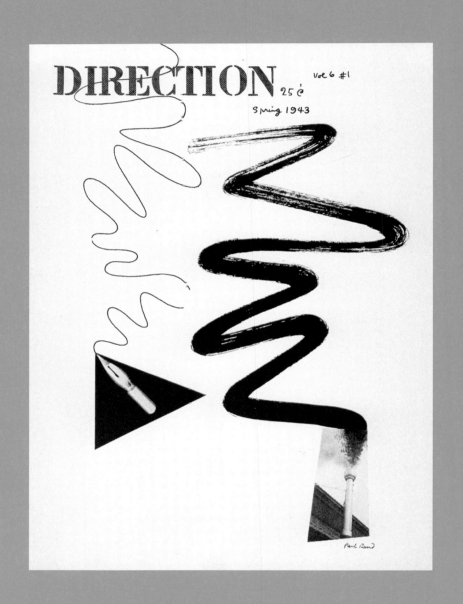

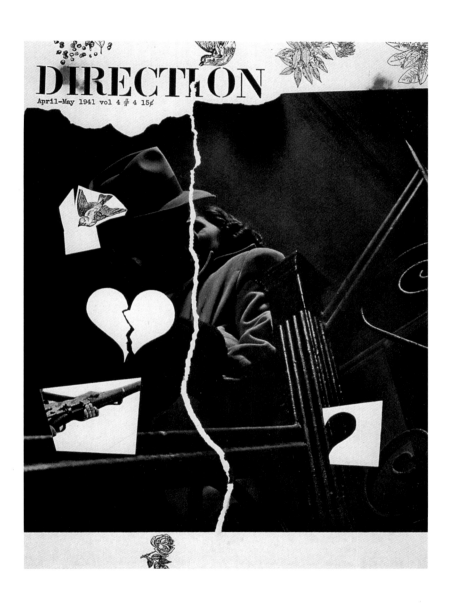

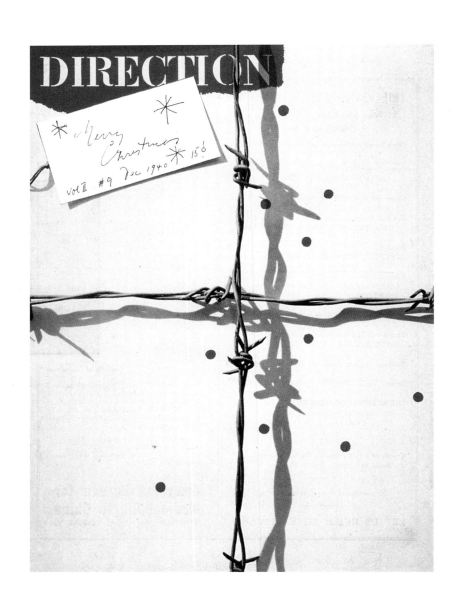

62.

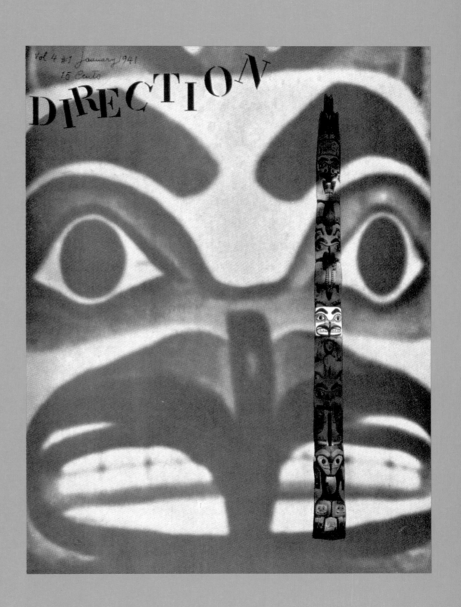

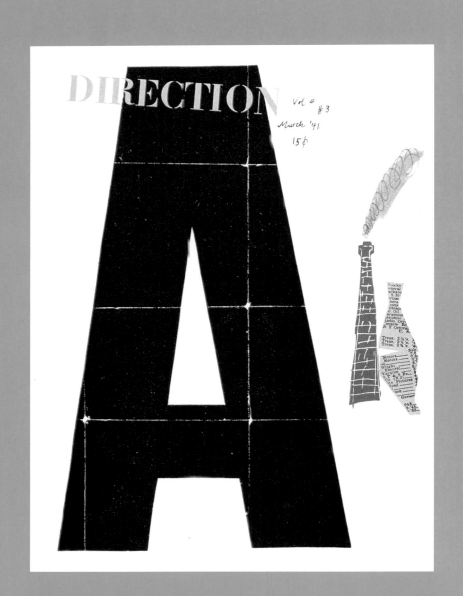

DIRECTION

Vol 4 #3
March '41
15¢

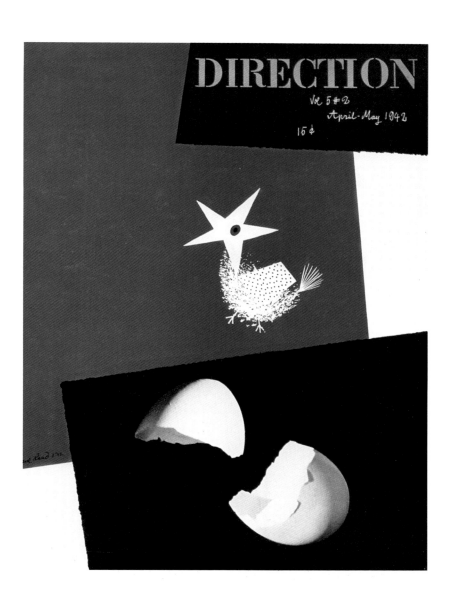

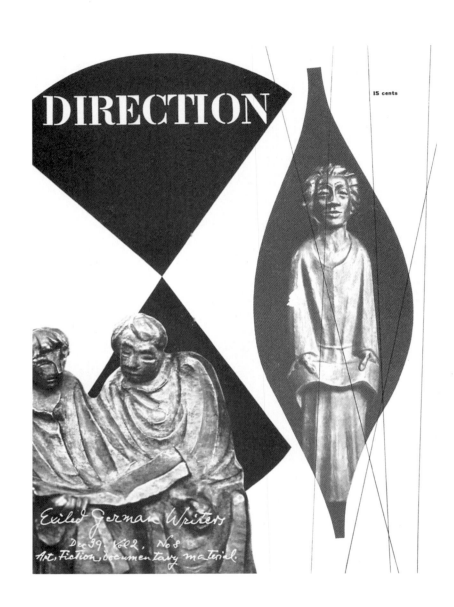

DIRECTION

15 cents

Exiled German Writers
Dec 39, Vol 2, No 8
Art, Fiction, documentary material.

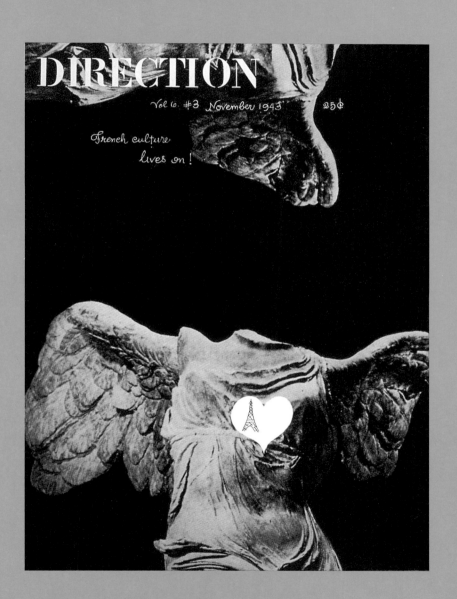

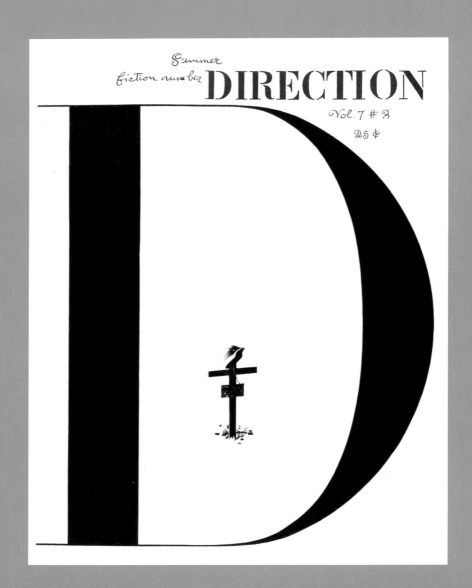

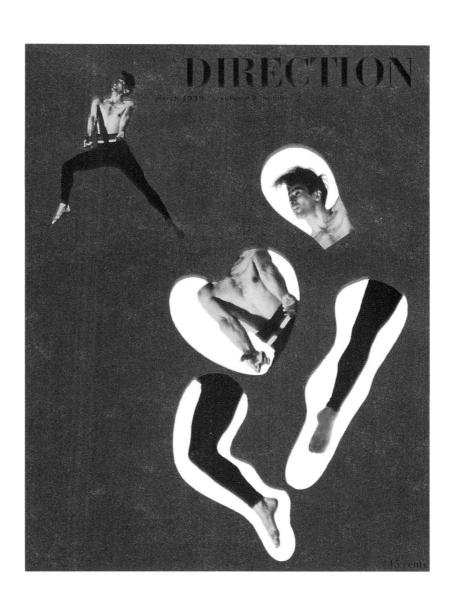

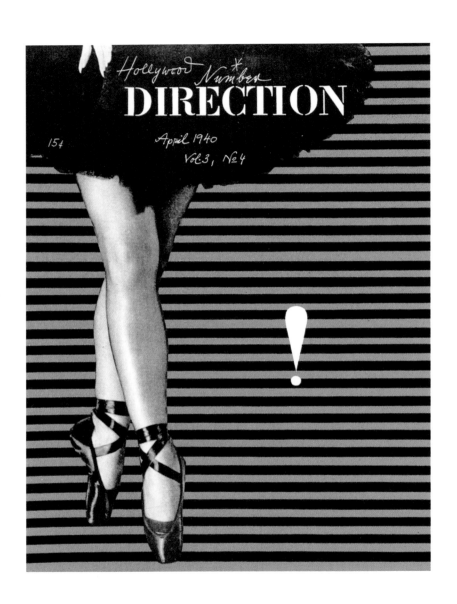

70.

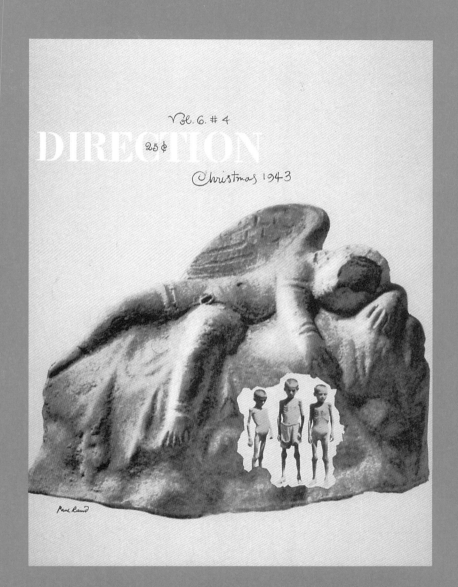

Poster (Art?)

The poster is really an enlarged
postage stamp, and the postage stamp
a miniature poster.

The art of the poster, like the art
of painting, is an art in which risk plays
some part, which can create problems
in selling an idea both to a client and to
the public.
It is also a problem in communica-
tion, in form, and, God help us, in pub-
lic relations.
What is the purpose of the poster?
Is it to persuade, to sell, to inform, or to
amuse?
Responding to such questions demands
experience not only with history, design,
and marketing but with the psychology
of selling, the philosophy of aesthetics,
and the drama of communication.
Brevity and wit play a role, as do talent,
good fortune, a receptive and intelligent
client, and an audience conditioned to
accept good work.

We have all heard how wonderful the
posters of Toulouse-Lautrec are and
how effective they were in attracting the
dance-hall buffs and the hoi polloi
of Paris. (In the same breath, we are re-
minded as well of Lautrec's debt to
the Japanese print.)
For the most part, a perusal of the
commercial poster today would make
Monsieur Lautrec wince.
It is a model of poor design, careless
typography, and lackluster illustration,

a medium in which sex, blatancy, trendiness — even mind-boggling computer images — play a significant role.

The best posters are rarely created for, or accepted by, manufacturers of soap or breakfast cereals, products that are aimed at vast audiences.
Rather, they tend to be designed for nonprofit institutions by artists who spend endless hours at these so often pro-bono chores.

Besides the great posters by artists of the past — A. M. Cassandre, Paul Colin, and E. McKnight Kauffer, among others — some of the most beautiful and effective posters (like this one for a circus) have been designed by such artists as Henryk Tomaszewski for an art gallery, rather than for a manufacturer of consumer products.

Cultures vary, as do habits and needs; but is a circus-goer more sophisticated than a soap-buyer ?
Why can't posters for the marketplace rise above the commonplace ?
The real culprit is the business community's fear and mistrust of the nature and/or relevance of good design — of design's importance as a cultural necessity, as a social responsibility, and as a sensible vehicle for sensible business.

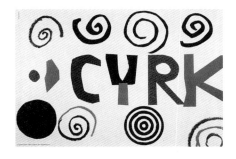

Henryk Tomaszewski
Circus Poster
Academia Sztuk, Warsaw

The degree of interest a picture
holds is often determined by its abstract
quality, which is the artist's critical
commentary, expressed with emphasis
on interpretation rather than on
verisimilitude.
The abstract also provides room for the
imagination to roam.

Compared to a commonplace political
poster, Miró's poster at right, which is
highly stylized and almost abstract, is in
literal and artistic terms dramatically
more expressive.

"The art that is frankly decorative
[abstract] is the art to live with.
It is, of all visible arts, the one
art that creates in us both mood and
temperament.
Mere colour, unspoiled by meaning, and
unallied by definite form, can speak
to the soul in a thousand different ways.
The marvels of design stir the
imagination....
By its deliberate rejection of Nature
as the ideal of beauty, as well as
of the imitative method of the ordinary
painter, decorative art not merely
prepares the soul for the reception of
true imaginative work, but develops
in it that sense of form which is the basis
of creative no less than of critical
achievement."

75.

Numerals are abstract symbols.
They are the busy bees of the world of mathematics.
They announce births and deaths, weddings and anniversaries, happy and sad occasions.

The symbols UCLA 75 are abstract; they celebrate 75 years in the evolution of a great university.
In this poster, letters and numerals join in heralding a momentous event.

Letters animate the inanimate; they are surrogates for speech and potentials for visual expression.
The illustration, at left, that appeared in the *New York Times* op-ed page, September 21, 1995, was designed to dramatize the editorial "Art by Committee." It shows how letters can be manipulated to help elucidate complex concepts.

Getting back to the UCLA poster, compare this design, at right, with the one on page 78.
Is the flowered design more human? Yes and no; it is a study of flowers, a collage of abstract elements, a conflict between hard and soft, black and white, red and green, letters, numerals, and petals, a contest between form and expression, between objects and ideas. *It is an exercise in aesthetics*, as is the design on page 77 — or any work that is concerned with formal values.

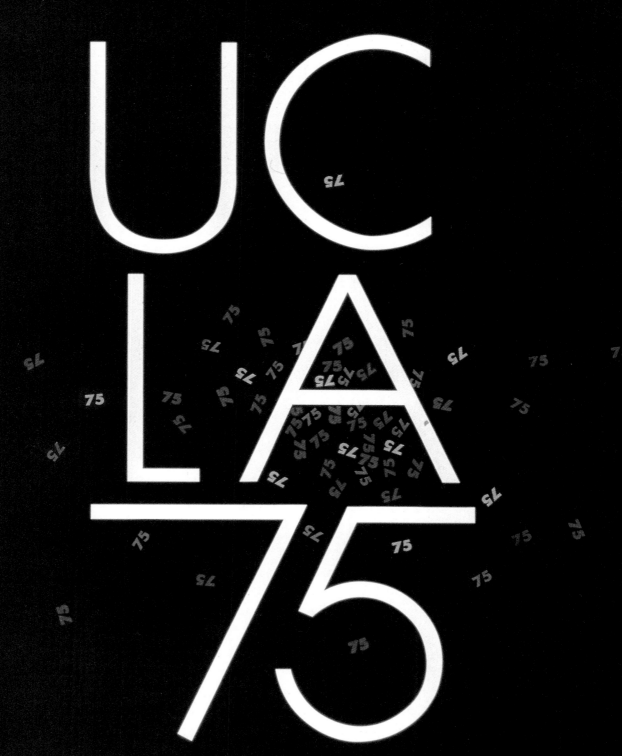

Poster (Art ?)

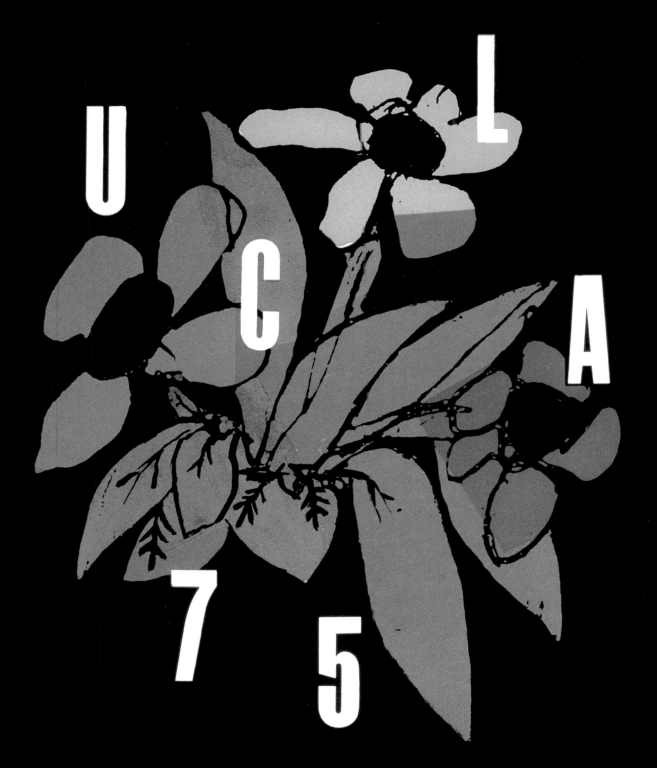

78.

Paul Rand

Failure by Design

Because design is so often equated with mere decoration, it is safe to assume that few people understand what design means or the role it plays in the corporate world. Graphic design pertains to the look of things — of everything that rolls off a printing press, from a daily newspaper to a box for corn flakes. It also pertains to the nature of things: not only how something should look but why, and often, what it should look like.

Why then do design programs in large corporations seem to be going out of style? Why is the average graphic design effort today merely average at best? Is the paucity of good designers and good CEOs possibly the reason for the paucity of good design? The Arco Oil Company began to lose interest in its design program when its chairman Robert Anderson departed. The highly acclaimed CBS design program began to erode when William Paley and Frank Stanton were no longer active.

One rarely hears of the program that put Westinghouse on the design map. And when Walter Paepcke, the CEO of the Container Corporation of America, died, why did the flow of distinguished advertising by world-famous painters and designers cease? Is it mere coincidence that when Rawleigh Warner departed, Eliot Noyes's elegant designs for Mobil stations were aesthetically downgraded?

When my friend Giovanni Pintori left his company, the character and special quality of Olivetti design no longer reflected the same passion and brilliance of an almost never-ending stream of graphic design works.

Without the enthusiasm of Adriano Olivetti, its founder, there might never have been a design program.

Tom Watson, who almost singlehandedly created the IBM design program, was not only its guiding spirit but was deeply concerned with its product; he always believed that good design is good business. In fact, years after he had left the company and the IBM design program had taken a different turn, he nevertheless was instrumental in rescuing the now-famous rebus poster (the IBM picture logo) from oblivion, when it was questioned by other executives.

That so many programs for large corporations have had a short life span is no evidence that design is impotent. What is evident is that management does not really appreciate the contribution that design (art) can make socially, aesthetically, and economically.

"Art," said John Ruskin, "represents a social necessity that no nation can neglect without endangering its intellectual existence."

Yet in the world of commerce, with the exception of the lucky, talented, passionate, or aggressive few, designers are neither appreciated nor understood. For the most part, they are consigned to a low rung on the corporate ladder. Similarly, it is the tendency of most businesses to appeal to the consumers' lower instincts rather than to their higher ideals.

But is poor design exclusively the domain of the CEO ? There is also the problem of visual literacy, a common language between designer and client. Unfortunately, just as there are managements unwilling or enlightened enough to commission good designs, there are designers who are eager to accommodate their every whim.

Moreover, good design cannot be dictated or willed; alas, it is not the product of market research but of natural talent, relevant ideas, and mutual respect, without which design programs eventually will unravel and good design wither away.

Design can help inform, delight, and even persuade —
assuming that the designer is an artist and not just
someone focused on the nonsense of "self-expression"
or on the fads of the moment.

"Most people," said the painter Robert Motherwell,
"ignorantly suppose that artists [designers] are
the decorators of our human existence, the esthetes to
whom the cultivated may turn when the real business
of the day is done ... Far from being merely decorative,
the artist's awareness is one of the few guardians
of the inherent sanity and equilibrium of the human
spirit that we have."

82.

The Logo as Illustration

A logo, meant for print or television, is designed primarily as a means of identification.

Some logos can do more; they can help sell a product, an idea, or an ideal; the Cummins logo does both.
But this function must be *designed* for print *or* television and must be *built* into the basic design at a critical stage of the design process.

There are few logos that provide such opportunities.
Simplicity is the key to these problems.
Illustrative material that is too complex is self-defeating.
The design must not conflict with the legibility of the logo.

The illustrations that follow show the difference between simple and complex solutions.
The illustration on page 84 (left), for example, is self-explanatory, but it is the least convincing of all the designs.

Simplicity is never a goal ; it is a by-product of a good idea and modest expectations.

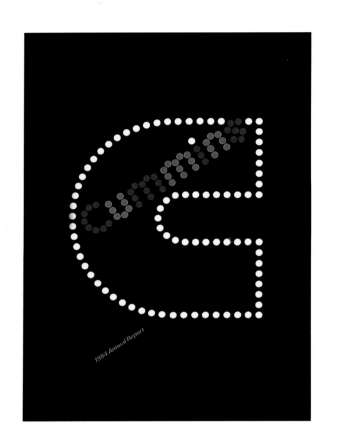

1984 Annual Report

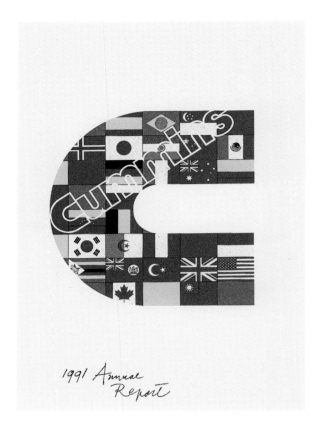

1991 Annual Report

86.

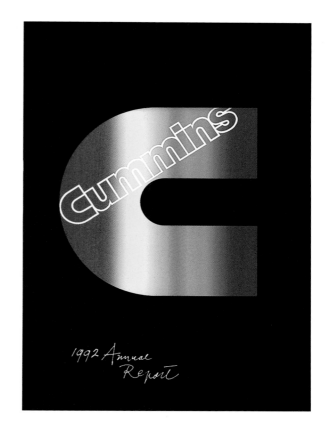

87.

88.

89.

When subject matter is nonrepresentational,
as in this composition derived from the word Cummins, *the question of
meaning is no issue — a song without words. (See page 87.)*

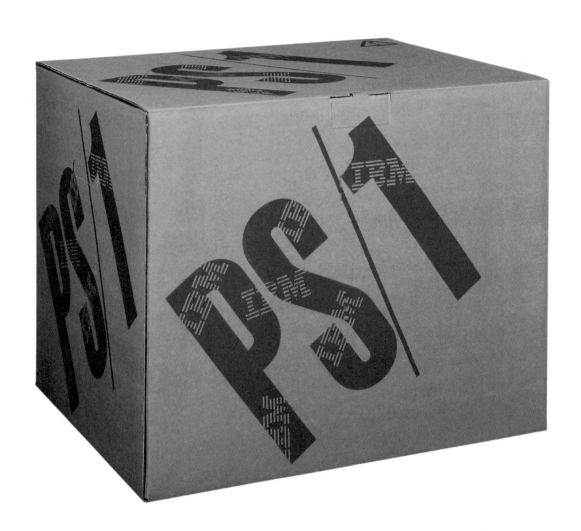

90.

A work of art is realized when
form and content are indistinguishable,
when they are in synthesis.
When form predominates, meaning
is blunted; when content predominates,
interest lags.

"All forms are expressive, and the
content of the work is the meaning of
the forms as representations
and expressive structures; therefore,
content and form are one."

Meyer Schapiro,
Theory and Philosophy of Art
(New York, 1994), 41

Ideally, identity and product are one.
The IBM PS/1 logo serves a dual pur-
pose: it helps to establish and
authenticate a new product at the same
time that it combines product and
logo as an integrated unit.
This is possible only when each compo-
nent is designed to accommodate
the other; they must be simple enough
to make this union possible.

Structurally, this design is a study
in contrasts: the angle of the logo in rela-
tion to the perpendicular sides of the
carton; the use of small random logos in
comparison with large regimented
letters; the thin stripes of the logo com-
pared to solid bold letters; a thin slash
played against thick letters; condensed
type versus regular type.

Four Presentations

A printed presentation is a designer's modus operandi — a silent salesman — a graphic demonstration, informed and authoritative, but not an object of self-aggrandizement.
It is a lesson devised to help a prospective client understand the connection between design and business.
The designer-client relationship, ideally, is like the doctor-patient relationship : mutual trust is the common denominator.

To explain the design process, multiple choices may be explored.
But the choice should not be left to *focus groups*, but to those whose expertise, experience, and track record a sophisticated client will respect.

No matter how logical a design may be, unless the audience has a sympathetic eye and ear, unclouded by the machinations of consumer polls, a designer's presentation cannot withstand the rhetoric and specious arguments of the skilled marketer and researcher.

A consumer survey cannot predict the long-term benefits of design, nor can it evaluate the contributions of an experienced designer.
Only time can elucidate such mysteries.
A survey can disclose facts, demographics, and opinions but not a future response or reaction.

"...the real art form of our day is marketing. It is an odious art. It's the lowest and the foulest and the filthiest and most obscene of all the arts."

Norman Mailer.
Art News (November 1995)

93.

Had the logos for ABC, Westinghouse, UPS, IBM, and Cummins been subjected to consumer surveys, they might never have been adopted.

"Art is a mode of prediction not found in charts and statistics, and it insinuates possibilities of human relations not to be found in rule and precept, admonition and administration."
Dewey went on to say, "An artist in comparison with his fellows, is one who is not only especially gifted in powers of execution but in unusual sensitivity to the qualities of things.
This sensitivity also directs his doings and makings."

John Dewey,
Art as Experience
(New York, 1934), 349

"Through the exercise of the sympathetic imagination, art, more than preachment or moralizing, tends to reveal the common human nature that exists in all men behind the facade of divisive doctrines, and thus to unite mankind more effectively than the doctrines themselves could ever do.
This is (to use Dewey's term) the 'leavening' influence of art."

John Hospers,
The Encyclopedia of Philosophy
(New York, 1967), 51

Following are four presentations: some have been altered to accommodate the format of this book.

I.

Okasan Securities Company
Tokyo, Japan

(1991)

95.

The design of a logo is often arbitrary — the product of a whim.
If, for example, in a given project letters are to be used, the effect depends almost
entirely on the abstract quality of the design and the euphony of its
expression, rather than on any substantive idea. It is rare that a logo will contain
an idea that, at the same time, is part of the company name.
Embodied in the name Okasan are the letters OK, which, by chance, are both
full of meaning and universally understood.

Following is a demonstration of the evolution of the new Okasan logo, beginning
with the original logo.

96.

98.

To make the ordinary extraordinary is the purpose of design. Viewed normally, the OK symbol may seem commonplace; turning the letters 90° adds an element of interest and curiosity, qualities that are both desirable and engaging. This change provides the spectator with the pleasure of participation and the satisfaction of discovery. Turning the letters sideways evokes an anthropomorphic figure — a better memory-aid than mere initials. The purpose is to make the image not only easy to remember but easy to draw. The addition of the circle carries, however remotely, some connection with the original logo; it also serves as a focal point, or target, while it isolates the figure from its surroundings and adds an element of contrast to the lines within its perimeter.

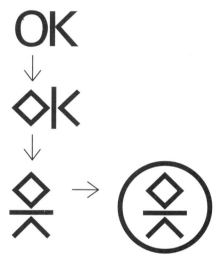

In *The American Language* (1957), H.L. Mencken devotes four pages to the etymology of the expression "OK." From its humble origins (recorded circa 1840) it has become one of the most widely used phrases in the American language, as well as part of the language of Western Europe and Asia. Some years ago the British Privy Council decided solemnly that it was *good English*. For the International Telecommunication Industry it means *we agree*. OK is the essence of brevity, simplicity, and economy, the symbol of agreement and approval, and it has the ring of good cheer and friendliness — an expression ideally suited for a business that deals with people and finance.

103.

The company name (usually difficult to integrate with a logo) is treated as an organic part of the design, almost inseparable frcm the logo.
The two elements have become one. Breaking the name in two lines does not affect its readability but adds to its uniqueness and recognizability.
Two weights are provided, light and bold, for convenience in solving design and/or production problems.

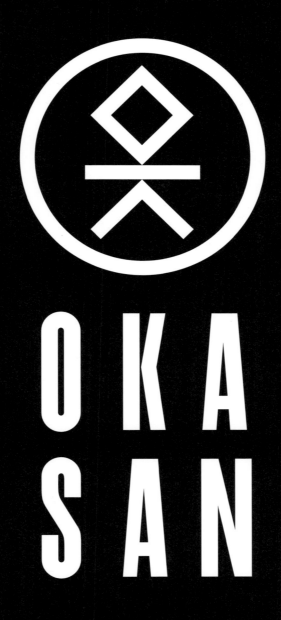

OKA
SAN

The variations possible for signage and video animation, as well as printed material, are almost endless, as demonstrated in this sequence beginning with the old logo evolving into a new one, repeating the final version, and, lastly, displaying the name.

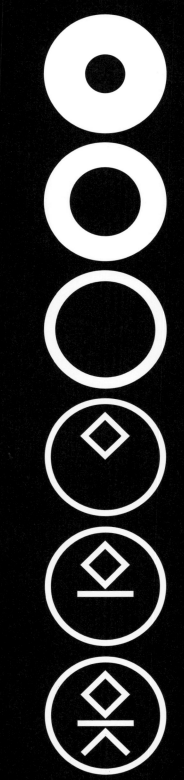

108.

EF English First
Stockholm, Sweden

(1993)

Four Presentations

A Logo For EF

The EF Company is composed of worldwide language schools and travel offices.
English accounts for 85 percent of the language programs, which explains both the initials (which existed long before the name was chosen) and the name English First.

A logo is the graphic distillation of a company's beliefs, management, and products. Its principal purpose is to call attention, to point, to identify. Like a signature or thumbprint, a logo is unique. It represents the particular and helps to define the business it symbolizes.

Most logos are non-defining, like Chanel and IBM, and they achieve a recognition that is directly related to the time, effort, and expenditure invested. The design of some logos is based only on formal consideration, others on arbitrary or even irrelevant ideas.

Less common are designs that are self-explanatory: that either illustrate or intimate what a corporation is or does.
The United Parcel Service logo, for example, fits this genre, as does the design for English First. To be effective, both types of design must be exposed; to be remembered, they must be memorable; to be recognized, they must be nurtured, explained, and exploited.

*Here are some preliminary trials: with the exception of
the simplest logo, showing the E and F as a single letter, the other designs are
defining or descriptive, ideas that relate to the business of language,
with the alphabet serving as a springboard.*

*These ideas were abandoned, however, not because they were
inappropriate but because they were imperfect. Since the EF logo will be
used in tandem with other copy as an active part of a particular design,
it was felt that the transition between the EF and accompanying copy was not
sufficiently smooth; the alphabet seemed to get in the way of the other text.*

116.

What you have just seen is the embryo of a graphic idea.
The most trying part of any design problem, especially the design of a logo,
is to find an idea that visually epitomizes an enterprise of some sort
and that is also both appropriate and utilitarian. Formalizing it (pinning it down
on paper) is the next most difficult step.

The sound-wave pattern serves a clear purpose. It is conceptually and
graphically appropriate; it provides a visual device that is both decorative and
mnemonic and that is easily incorporated as an organic and inseparable
part of the logo. The pattern provides a needed contrast to the straight lines of
the EF ; the italics add emphasis.

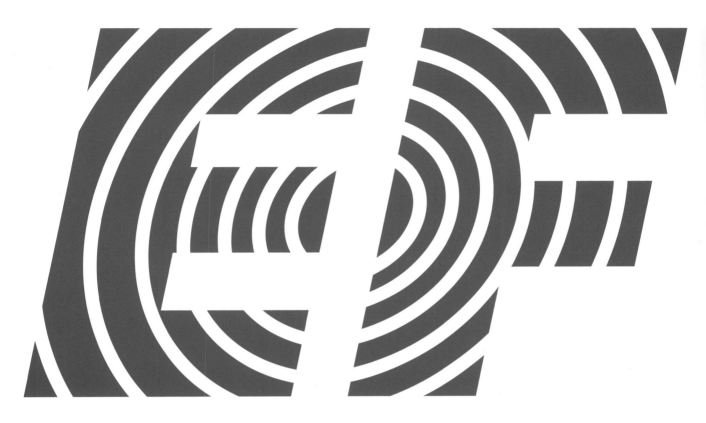

 English
First

Here are a variety of typographic treatments:
Long lines of type should be avoided; they are difficult to read and connect
awkwardly with the logo.

 Språkresor

 *International
Language Schools*

 *International
Language
Schools*

.

 *English
First*

 *Language
Travel*

*Educational
Tours*

How a logo is implemented may contribute or detract from its clarity, its precision, its grace. For the typography of a letterhead or calling card, for example, precision is vital. Measurements are made in points; type sizes are an important part of any design, because they determine scale and proportion. Dimensions of margins are as important as type measurements.

English First

Sturegallerian 11A
Box 5761
11487 Stockholm, Sweden
(+46) 8 679 30 00
Fax: (+46) 8 611 50 11

One Memorial Drive
Cambridge, MA 02142 USA
617 252 6000
Fax: 617 494 1389

123.

*Nothing is arbitrary: weights, sizes, spaces, and proportions contribute
to the gracefulness of a design. Color, printing, and choice of paper are also
vital considerations. Glossy papers should be avoided when readability
is affected. Matte, smooth papers are to be preferred to glossy paper or artificial
textures. Paper weight is an important consideration as well; paper that is
too heavy is clumsy, too light, flimsy.*

Göran Casserlöv
Corporate Controller

 English
First

Grav Turegasan 11A
114 46 Stockholm, Sweden
46 (0) 8 679 30 37
Fax: 46 (0) 8 611 50 11

9 / 7.5 Helvetica Oblique
5 / 7.5 Helvetica Light Oblique

7 / 8.5 Helvetica Light Oblique

English
First

Sturegallerian 11A
Box 5761
114 87 Stockholm, Sweden

8 / 9.5 Helvetica Light Oblique

At best, a logo can be a potent sales aid and, at least, an interesting decorative device. A well-designed logo, besides enhancing whatever it adorns, encourages repeated use. Discretion, ingenuity, and attention to small details as well as to total effects should be constantly in the designer's awareness.

A logo that is inexpertly applied, too big, too small, inaccurately matched in color, or cheaply printed is self-defeating. Professionalism is a reflection of a company's ethics, its employees, and its products.

A logo is great only when the company it symbolizes is great.

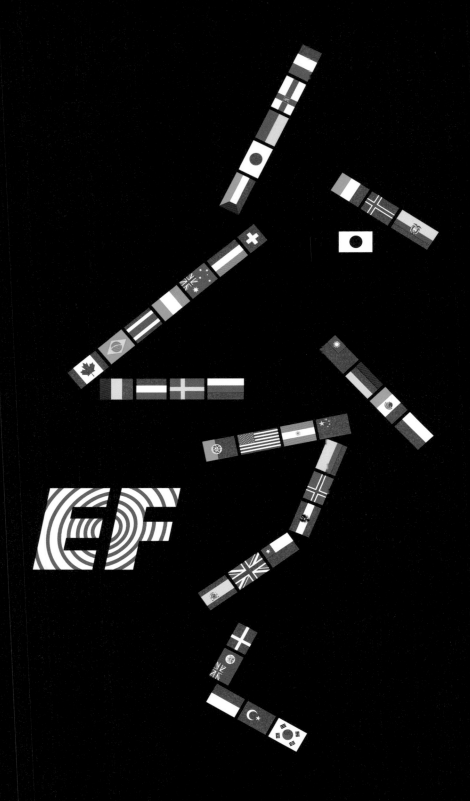

Learn a Language !

In normal advertising practices the logo is used modestly, merely to authenticate or identify a product or a service. However, as previously indicated, the logo is potentially a perpetual sales support.

Flags are ideal symbols to express the concept of an international or worldwide institution. The flag profile of this poster is based on a visual metaphor in which three images — flags, a face, and the logo — are synthesized to convey a single message.

A B C D E F

G H IJ K L M

N O P Q R S

T U V W X Y

Z A B C D E

F G H IJ K L

M N O P Q R

3.

The design of
a logo
is largely the process
of intuition,
trial and error,
skill, and
good fortune.

The
ideal logo is
simple,
elegant,
economical,
flexible,
practical,
and
unforgettable.

What follows
is designed
to fulfill
these criteria.

133.

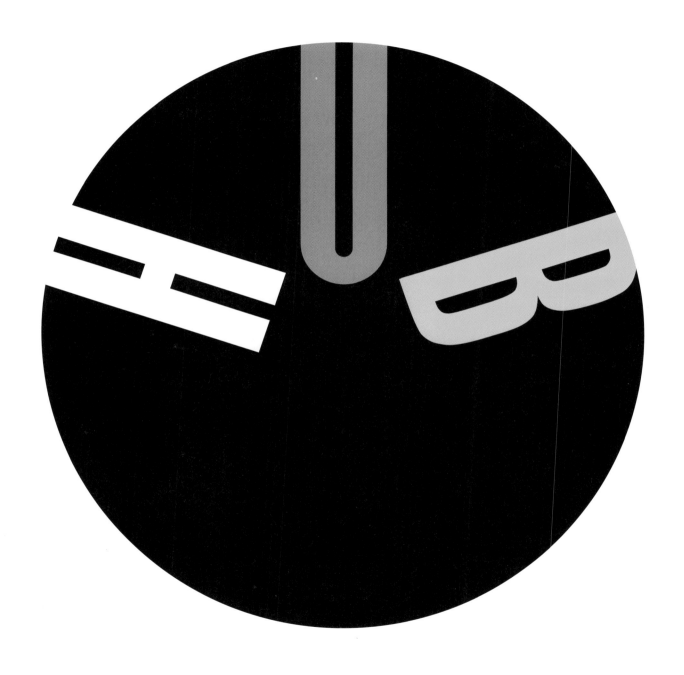

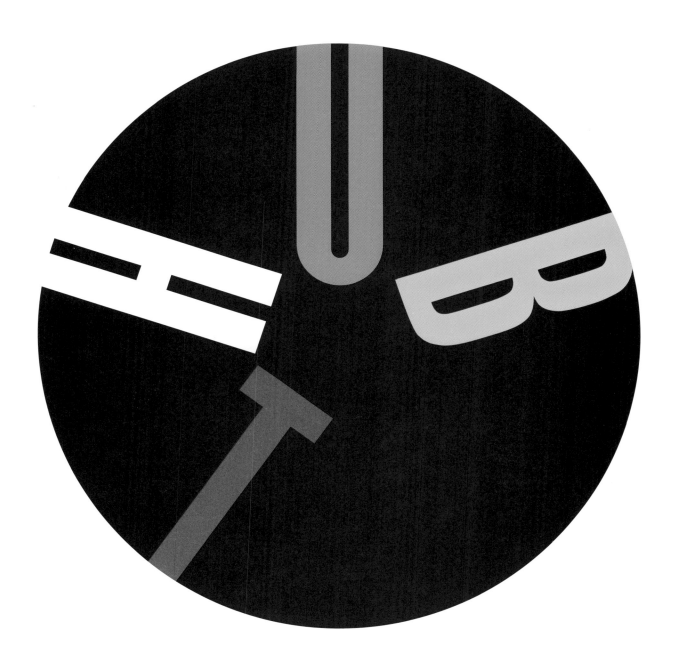

141.

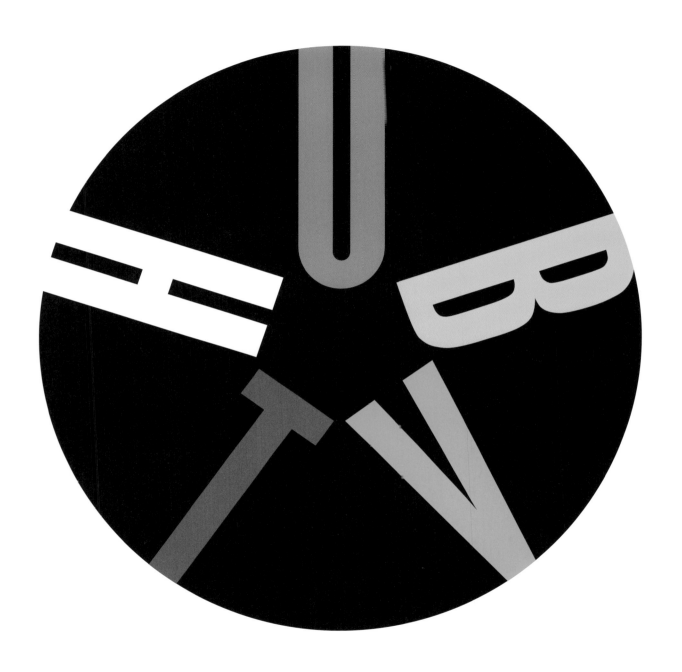

142.

The star
configuration
is a persuasive
symbol.
It is universal,
memorable,
adaptable.
It says *the best.*

Here, it
evokes the image
of a *hub*
and a
satellite dish.

These
are happy
coincidences
and useful
memory aids.

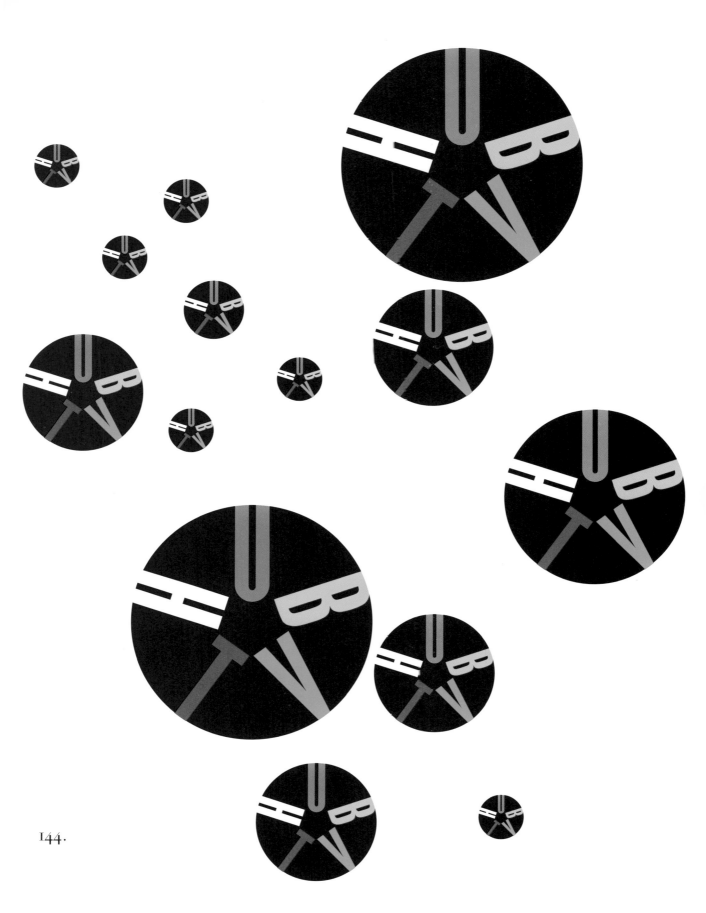

144.

4.

146.

The problem of designing a distinctive corporate trademark is twofold. First, the job involves decisions concerning the effectiveness and appropriateness of the design itself. These include considerations about the nature of the business the design will reflect, its international affiliations, and its subsidiaries.

Second, it involves such questions as the compatibility of the new design with existing company graphics, the problems of transition from old to new, and the rather serious question of implementation once the use of the logo is turned over to the corporate staff, or others.

147.

This proposed design attempts to avoid the cumbersome problem
of dealing with a symbol or monogram that must be explained by the addition of
a company name. The simplest and most effective solution, it seems,
is to combine both name and monogram into a single element.
This complementary relation makes a unique and easily identifiable sign.

Placed on an angle on the letter C (reminiscent of a rubber stamp), the
word Cummins adds a certain liveliness, as it explains and lends authority to the
symbol. The signature within the initial letter establishes a dramatic element
of scale. The total configuration, at the same time, suggests speed and power.

Structurally, the proposed design consists of four basic geometric
elements: the half-circle, the horizontal, and the diagonal — three contrasting
elements contained within a perfect square dimension. The square
measurement helps to facilitate visualization and will save time and effort
in fabrication.

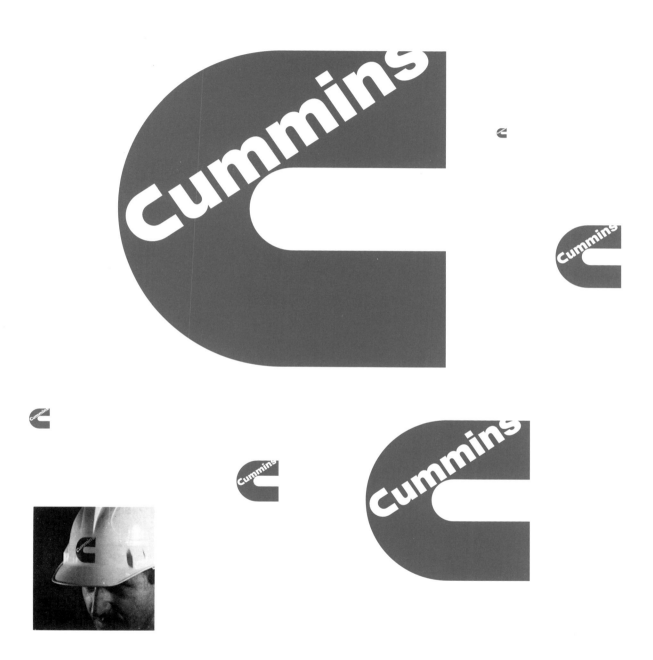

The design is not descriptive. Its universal character makes it all the more adaptable to a diversified business. This in no way reduces its effectiveness as a symbol for Cummins engines.

When distance or poor visibility makes the name illegible, the mark still retains its essential features. The distinctive profile makes recognition easy, even for those who cannot read the Roman alphabet, an important factor for a business with international ties.

Here are some variations in which substitutions for the company name are used. Maintaining the same angle and similar location makes association with the company name almost automatic. This play on words and forms lends additional interest, subliminally, to the basic mark.

150.

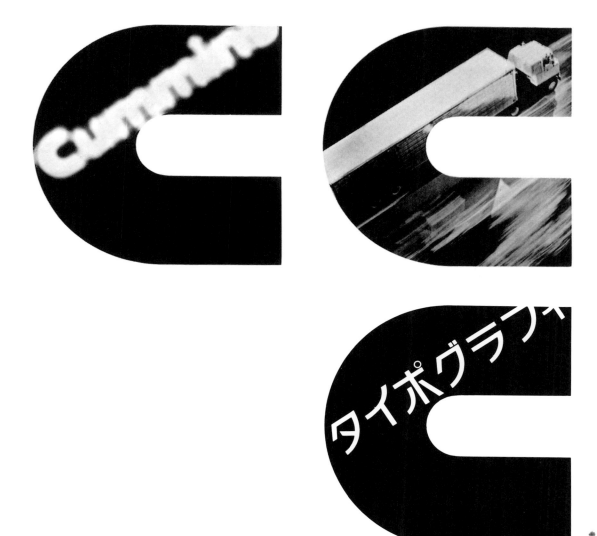

Jan
Tschichold
Versus
Max Bill

It was no breakthrough, like Picasso's *Les Demoiselles d'Avignon*; nevertheless, Jan Tschichold's *Die Neue Typographie*, published in Germany in 1928, fostered a different way of looking at typography. His views were based largely on modernist ideals: on cubism, in which a word or letter became surprisingly revealing merely by becoming part of a collage; on the unorthodox writings of Mallarmé; on futurism and the typographic leanings of Marinetti; on the seemingly wild ideas of dada, the revolutionary ideals of constructivism, and the new conception of space, with its emphasis on two-dimensionality; and on the benefits of machine-setting as opposed to the archaic methods of hand composition. All this gave it its appeal.

But it also came as a surprise when, some years later, Tschichold abandoned the new typography (and its possible perils) for the comforts of the old, which he embraced with equal fervor. On the surface, Tschichold's about-face seemed merely a matter of substituting one allegiance for another; but for Tschichold this was a traumatic moment. "I detected most shocking parallels," he said, "between the teachings of *Die Neue Typographie* and National Socialism and Fascism. Obvious similarities consist in the ruthless restriction of typefaces, a parallel to Goebbels's infamous *gleichschaltung* [political alignment] and the more or less military arrangement of lines."

Given the horrors of the Nazi regime, this emotional reaction is not surprising, but the parallels, I believe, are grossly exaggerated. Tradition, nostalgia, and the persistence of symbols are among the possible culprits more likely to have swayed his beliefs.

155.

Tschichold versus Bill

Tschichold's renunciation of the new inadvertently led to a fiery debate with the avid modernist, concrete painter, sculptor, and architect, Max Bill. The debate was conducted only in print and lasted a short time — at least in that form. In a letter to me, dated November 19, 1946, Bill wrote: "I'm sending you my answer to Tschichold's attack on me in the *Schweizer Graphische Mitteilungen*. The editors requested a response, but did not have the courage to publish it." The unpublished response was in the form of a play entitled *Little Typography Theater for Outsiders*, in which Tschichold was depicted sitting on a rock holding a "middle-axis" (an imaginary center line) in his left hand and a goose quill in his right. Highly sarcastic, this play was nevertheless an index of the passion that motivated both antagonists. But as we shall see, the passion that inspires may also blind. In closing his letter to me, Bill expressed his feelings vehemently: "Tschichold is leaving Switzerland and so we will be rid of the evil we invited in the first place."

The attack that Bill refers to was published in June 1946, under the title "Belief and Reality." "The half-understood, grossly distorted quotation from my lecture," said Tschichold, "must have come from second or third hand. Without having informed himself of the source, Bill used this information for a fanatical attack on book typography as practiced by myself." Further, Tschichold talks about the new typography meeting a dead end: "This truly ascetic simplicity soon reached a point where no further development was possible." Until one has exhausted all possibilities — and possibilities are inexhaustible — this statement seems curious.

In today's topsy-turvy artistic climate, the controversy about the new vs. the old typography that engaged Bill and Tschichold might have been so politicized that real issues would have been buried under a pile of social irrelevancies. In the jargon of today Bill, probably, would have been dubbed "cutting edge" and Tschichold "archaic." But 1946 is not 1996. Debates then were clearly articulated, uncontaminated by side issues. Even though these debates were far from friendly, the issues were nevertheless quite clear. Today, however, in an environment in which competence is in question, frivolous decoration is rampant, and mishmash is the message, clarity is a liability.

What are the real issues ? Typography, symmetrical or not, is an abstract art. Typography does not deal with chickens or rabbits but with symbols—abstract symbols. The same symbols are used in both symmetrical and asymmetrical arrangements. There are badly designed typefaces (serif or sans serif) and well-designed typefaces (serif or sans serif), as well as distinguished and mundane title pages in either mode. In addition to the fact that traditional typography is centripetal and modern typography is centrifugal, differences that separate modern from traditional typographic design are as follows:

1. asymmetric orientation of text and pictures
2. articulation of outer edges
3. avoidance of symmetry and decoration
4. minimalization of capitals
5. preference for sans serif
 (not to the exclusion of serifed faces).

Regardless of preference, however, the symbolic association of sans serif typefaces with modernism cannot be avoided. Discretion, keen observation, delicate insight, and sensitivity to form are indispensable qualities for practitioners of either style. Habits, associations, and experience will ultimately determine preferences or prejudices.

In an article written for *Circle* (1937) Tschichold refers to traditional typography as the New Traditionalism and illustrates the differences between new and old typography in the following table:

Jan Tschichold,
"The New Typography."
Circle (1937), 249

New Traditionalism	New Typography
Common to both	
Disappearance of ornament. Attention to careful setting. Attempt at good proportional relations.	
Differences	
Use of harmonious types only, where possible the same.	Contrasts by the use of various types.
The same thickness of type, bolder type prohibited.	Contrasts by the use of bolder type.
Related sizes of type.	Frequent contrasts by the use of widely differentiated types.
Organization from a middle point (symmetry).	Organization without a middle point (asymmetry).
Tendency towards concentration of all groups.	Tendency towards arrangement in isolated groups.
Predominant tendency towards a pleasing appearance.	Predominant tendency towards lucidity and functionalism.
Preference for woodcuts and drawings.	Preference for photographs.
Tendency towards hand-setting.	Tendency towards machine-setting.

In his article Tschichold explains New Traditionalism as proceeding from an "earlier feeling of space," as being, that is, symmetrical.

Both Tschichold and Bill were distinguished practitioners in their fields. Neither was concerned with crackpot ideas, both with matters of principle. Both were sincere in their beliefs, yet they were equally insistent and equally rigid, one obsessed with modern, the other with traditional typography.

Unlike the situation that exists today, theirs was a war between period styles only, not intrinsic values. In fact the question of quality never entered the arena. But the question of art did. Tschichold was not immune to the old shibboleth that anything that involved utility — type or telephones — could not aspire to the pinnacles of art. "We should not think that a properly designed telephone is a work of art," he said. Aesthetics cannot be separated from typography, any more than it can be separated from any other art.

At the same time that he maintains that "the New Typography is well suited for publicizing industrial products," Tschichold admits that asymmetry is not so easy to accomplish. "Traditional typography which can be easily understood by everybody... in the hands of a beginner does not permit nearly so many blunders as the new typography in the hands of the uninitiated." Later he noted: "Every asymmetrical arrangement needs its own individual design. Asymmetry is a secret known to a group of initiates and not easy for the average compositor to acquire."

It is no revelation that each style presents difficult problems. Traditional typography looks easy because balance, which is the sine qua non of good design, is achieved merely by centering. Yet there are few good title pages, even of the conventional kind, although there are more bad ones in the modern style.

It is not as easy to achieve perfect balance with asymmetry, even for the initiated — traditional typography may look dull and unimaginative, the new typography merely pretentious or disjointed.

Tschichold even offers more than a hint that asymmetric typography wasn't so bad after all: "All of Bill's books," he admitted, "show a great feeling for form and sure taste; of their kind they are exemplary." Clearly, Bill's books and posters are examples of typography at its best — with or without the aid of serifs. And, speaking of symmetry, Tschichold often contradicted himself (as in *On Typography*, published in 1952): "Nor is asymmetry in any way better than symmetry; only different. Both arrangements can be good." In the same essay he writes, "In typography neither the old style nor a new style matters; quality does."

But it is clear that even though Tschichold granted the validity of asymmetric typography and grudgingly permitted the use of sans serif typefaces for advertising and for purposes other than book work, his heart was really in conventional layouts and serifed typefaces. His designs for the pharmaceutical firm of Hoffmann-La Roche are ample evidence of his preferences.

Good typographic practice does not depend on the use of serifs or sans serifs. An experienced typographer, aesthetically oriented, can deal with both. Appropriateness is as good a guide as any. The "look," however, created by the use of sans serif type is subtle yet unmistakable. Whether it is more difficult to read than serifed type is questionable. Serif or no serif is subject to so many factors that one cannot say with certainty that one is more legible than the other. Habit too often influences our decision; and habits have a habit of causing uncertainty.

Must a designer know how to set type? "It is doubtful," opined Tschichold, "that a graphic artist who cannot also set type can come up with a good and useful graphic design." This is tantamount to expecting an architect also to be a plumber. It is true that students with typesetting experience understand the mechanics of typography, but there is little evidence that they have become better designers for it. This is especially true of those proficient with the computer.

Jan Tschichold,
Cover design
for Hoffmann-La Roche & Cie
(Basel, 1965)

But proficiency in craft is not proficiency in design. Cézanne's craft can hardly match a skillful illustrator's, yet Cézanne was a great creative spirit. Type houses are, or were, full of skilled typesetters, yet few can be called typographers. One can make a case for or against the place of crafts in design. This is not to suggest that proficiency with the computer is intrinsically bad — not at all. It is simply a matter of distinguishing between process and substance.

Tschichold and Bill's debate might never have taken place had the focus been on quality rather than style, and style has nothing to do with stylishness or being in style. A style is the consequence of recurrent habits, restraints, or rules, invented or inherited, written or overheard, intuitive or preconceived. The style of Vivaldi's music, Bonnard's paintings, or Mies van der Rohe's buildings is a product of distinctive sounds, uncommon viewpoints, and structural and spatial originality. But the quality of any work depends not on its style but on the special relation of form and substance. Style is merely a by-product — unless trends are more important than substance.

Ironically, the old and new typography seem to have more in common than they have differences. In today's parlance they are not mutually exclusive. Compare, for example, Tschichold's title page (right), to the example from Theodore Low DeVinne's great book *The Practice of Typography* on page 164.

Crucial to both is cognizance of formal relations, an in-depth understanding of the problems of readability, and finally, discretion in the use and/or the avoidance of popular or voguish typefaces. Both styles adhere to certain constraints, standards, or rules of order. If you agree with one you see it as reasonable; if you disagree you see it as doctrinaire or archaic. After all, evolution, which is what the new typography is about, is not revolution. The difference between modern and traditional typography is not the difference between apples and oranges. It is more like the difference between Granny Smith and Golden Delicious.

Jan Tschichold:

Typographische Gestaltung

Benno Schwabe & Co . Basel 1935

Theodore Low DeVinne,
The Practice of Typography
(New York, 1904), 311

THE

CYROPÆDIA

OR INSTITUTION OF CYRUS

AND

THE HELLENICS

OR GRECIAN HISTORY

LITERALLY TRANSLATED FROM THE GREEK OF

XENOPHON

BY

THE REV. J. S. WATSON, M.A., AND
THE REV. HENRY DALE, M.A.

LATE DEMY OF MAGDALEN COLLEGE, OXFORD

WITH BIOGRAPHICAL NOTICE,
CHRONOLOGICAL TABLE AND INDEX

LONDON
BELL AND DALDY
YORK STREET, COVENT GARDEN
1870

The principles that guided both styles were less utilitarian than formal. Contrast was a basic feature of each, even though interpretation was different. On the following page is a spread from DeVinne's *The Practice of Typography* that demonstrates the thoroughness that produced a particular typographic style.

Exceptional typographic work in any style requires originality, aesthetic sensibility, exhaustive knowledge of production, appreciation of fine printing, and an awareness of the subtleties and uses of printing papers. The difference, essentially, is that the old typography is based on the time-hallowed ideals of handwork, of Gutenberg, and of the scribes before him. It is also in harmony with the tenets of Stanley Morison and Daniel Berkeley Updike. It sees pictorial space by the conventions of the Renaissance and feels comfortable only when vanishing points meet on the horizon and when Euclidian doctrine is not tampered with.

The new typography, on the other hand, is based on the conventions of cubism and machine technology, with more than a passing glance at the old scribes, and at Gutenberg, Baskerville, Bodoni, Janson, and Caslon, as well as Cézanne, Picasso, Mallarmé, Marinetti, Mondrian, Van Doesburg, Duchamp, Moholy-Nagy, Le Corbusier, Lissitzky, Tschichold, and Bill.

Theodore Low DeVinne,
The Practice of Typography
(New York, 1904), 404-405

The title-page should not have too many lines, and the words oftenest used in giving a name to the book should constitute the line of largest display.

Where a preference is possible, this leading line should be the third line of the title.

The article attached to the word selected for the largest display may be put in a separate line, as in

LA

PHILOSOPHIE

When the words selected for largest display are too many for one line, they may be put in two or more lines, and one line should be larger, as in

THÉOLOGIE

MORALE

DES CURÉS ET DES CONFESSEURS.

When the noun that defines the subject-matter is followed by a qualifying adjective which contains more letters than the noun, the adjective should be in the larger type and make a full line:

THÉOLOGIE

SÉRAPHIQUE.

When the words are too many for one line, the preceding word, as Treatise or History, should be in the largest type even if it makes a short line.

TRAITÉ

DU

DROIT ECCLÉSIASTIQUE.

When all the words in three or more proximate lines need a bold display, care must be taken to prevent the formation of a cone, as it appears in

LEÇONS

SYNCHRONIQUES

D'HISTOIRE GÉNÉRALE.

The Evolution of Useful Things

by Henry Petroski, is a tantalizing book. Here, in the engineer-author's untechnical language, is a sample of its contents that is both amusing and revealing: "It is said to have been Cardinal Richelieu's disgust with a frequent dinner guest's habit of picking his teeth with the pointed end of his knife that drove the prelate to order all his table knives ground down." Not only does this book tell us about the evolution of such familiar artifacts as flatware, but it also tells us about the multitudes who designed and used them. Quoting from *The Evolution of Technology* by George Basalla, the author provides us with another interesting anecdote: "In 1867 Karl Marx was surprised to learn … that five hundred different kinds of hammers were produced in Birmingham, England, each one adapted to a specific function in industry or the crafts." This kind of information is fascinating not in spite but because of the familiar things it talks about.

The Evolution of Useful Things is as much a social history as it is a technological treatise, a description that also applies to Henry Petroski's previous books, *The Pencil* and *To Engineer Is Human*. All relate to everyday objects rather than exotic ones — how pins turned into paper clips; how styrofoam containers for hamburgers evolved; and how Post-it Notes came about. The list is endless, and it is easy to imagine that the author is well into his next tome

More, perhaps, than anything else, Petroski reminds us not to take things for granted. (His book is both an object lesson and a lesson about objects.) But this is not all he has to say. Supplying us with so many different artifacts, he has also tried to illustrate, with the help of some of his theories, the evolution of these artifacts.

In his preface Petroski describes his book as "a refutation of the dictum that *form follows function*." In its place he offers the debatable proposition that *form follows failure*. In this, I believe, he is skating on thin ice. "Here," Petroski asserts, "is the central idea: the form of made things is always subject to change in response to their real or perceived shortcomings, their failures to function properly." This hypothesis, it seems, is an assumption that is both too broad and too narrow. To claim, as the author does, that "this principle governs all invention, innovation and ingenuity" seems to be stretching a point, for it disregards those sources of inspiration that have nothing whatever to do with failure, mechanical or otherwise. It also fails as a unifying principle, simply because failure does not represent, as does function, the end of the design process.

If one, incidentally, were to take the maxim *form follows failure* at face value, the Leaning Tower of Pisa would make a striking example; but this, I doubt, is what Petroski had in mind. His concept of failure, even if a bit gimmicky, is interesting, but I doubt that it can be seen as a universal truth. Sophistry, somehow, is in the air. In the evolutionary process of an artifact, failure is merely one of a long list of incentives to change. The probability of failure as part of the evolutionary process of design is certainly a valid one, but so are the probabilities of need, want, order, chance, whim, obsolescence, fancy, faith, intuition, purpose, curiosity — and so on. Once something works, once a failure is corrected, the evolutionary process is complete — but only after function is realized.

Some of the author's other ideas, I believe, are equally difficult. "Whereas the shortcomings of an existing thing may be expressed in terms of a *need* for improvement," writes Petroski, "it is really *want* rather than need that drives the process of technological evolution. Thus we may need air and water, but generally we do not require air conditioning or ice water in any fundamental way." Anyone who has spent time in a movie house on a sultry summer's day surely will wish to spell want N-E-E-D. "We may find food indispensable," he continues, "but it is not necessary to eat it with a fork. Luxury,

rather than necessity, is the mother of invention."
The author forgets that there is such a thing as table
etiquette, and countless other things, that may turn
needs into wants and vice versa. This argument, carried
to its logical conclusion, would eliminate the need
for almost any artifact. Robinson Crusoe managed.

Many artifacts are changed for reasons that have
nothing to do with poor function, and even if they had,
this might not in any way affect their appearance.
Mechanical improvements do not necessarily create new
forms; failure is but one contributing factor among
many. Nostalgia and sentimentality are often more per-
suasive against change than is creativity. The old bridge
on Bridge Street, near the Westport railroad station,
built in 1884, is currently being restored to its original
state, rather than replaced by a modern structure.
(It originally replaced a wooden bridge built in 1869,
which was destroyed by termites.) Here, form follows the
bridge's original function. Postmodern design is also
steeped in nostalgia, as well as old forms, and not in
discovering new ones. The success of these structures is
due to their appeal to sentimentality and nostalgia.
Evolution that implies improvement is often no more
than mere restoration.

Here is another attempt to support the *form follows
failure* thesis: "Whether self-generated or heard from
others, whether couched in crass terms of coming up
with a million-dollar idea or in utopian dreams of waste-
less societies, whether expressed in Anglo-Saxon
concretions or in Latinate, polysyllabic abstraction, dis-
satisfaction with existing artifact is at the core of all
invention and hence all changes in made things." If the
idea of "dissatisfaction with existing artifacts" is not
limited to failure of some kind, there is clearly no basis
for disagreement. But in the evolution of artifacts,
preferences and prejudices are powerful forces, as are
innumerable other forces. Most of Thomas Jefferson's
inventions, for example, were the result of special
needs that had nothing to do with failure.

"Whereas shape and form," writes Petroski, "are the fundamental subjects of this book, the aesthetic qualities of things are not among its primary concerns. Aesthetic considerations may certainly influence, and in some cases even dominate, the process whereby a designed object comes finally to look the way it does, but they are seldom the first causes of shape and form, with jewelry and objets d'art being notable exceptions." This statement seems to imply that aesthetics, on the one hand, and shape and form, on the other hand, are mutually exclusive. In fact, though, there are many examples of artifacts besides jewelry and objets d'art that depend primarily on aesthetic considerations for their shape and form.

We know that a knife is a knife and that its basic form to fit its function was established long ago. Therefore, aesthetic considerations are really the only ones left for the designer who is asked to create a new knife. The Queen Anne pattern, pictured next page, for instance, which was designed almost three centuries ago, is perhaps the most beautiful flatware extant. Here the designer's problem had nothing to do with the shape of the blade, unless he chose to change it; functional considerations were not nearly as important as aesthetic ones.

"When aesthetic considerations dominate the design of a new silverware pattern," Petroski continues, "the individual implements, no matter how striking and well balanced they may look on the table, can often leave much to be desired in their feel and use in the hand." But the author has neglected to tell us that the opposite can also be true. A sensitive designer could have affected not only the appearance but also the function of the knife, which is exactly what the designer of the Queen Anne pattern did. He could have altered the relation between blade and handle or reshaped both so that they could be more comfortable to the hand *and* more pleasing to the eye.

172.

But none of this tells us anything about the role or even the meaning of form — the inseparable, aesthetic side of the equation. To those who have been complacently sharing the beliefs of true believers, of the sculptor Horatio Greenough (1805-1852), for example, or of the great American architect and mentor of Frank Lloyd Wright, Louis Sullivan (1856-1924), this must come as a surprise. Greenough says that "beauty is the promise of function," and Sullivan tells us that *"form follows function* is a rule of discovery and experience, and its implications would have more clearly been recognized if it had been stated: function creates form … functions seek their forms."

Does it work? is not only a question of function, it is also a question of form. Is it beautiful? Is it appropriate? Is it useful? These are some of the other concerns. What something looks like is its aesthetic quality, regardless of its purpose or function or whether it was designed by an engineer, or an artist, or by chance, intuition, or intention. The George Washington Bridge (1927, *see page 174*), incidentally, is a good example of design by chance. The steel skeleton that we know was originally intended to be clad in masonry, but lack of funds, not functional failure, determined its form — its soaring silver silhouette against the New York City sky.

Form follows function — or, more specifically, form follows the limits of restraint, simplicity, and economy.

Is the origin of the great monuments to culture the product of *form follows failure*? The Parthenon, the Mosque of Santa Sophia in Istanbul, and the great Gothic cathedrals are true products of human ingenuity and faith. Faith, I believe, plays a far greater role than failure in the production of most artifacts. The Shakers, for example, a religious, communal, celibate sect (sometimes called Shaking Quakers), produced some of the most beautiful and useful buildings, utensils, farm equipment, tableware, furniture, and tools. The invention of the circular saw, the flat broom, and the clothespin, for example, indicate that while the Shakers' heads were looking toward heaven their feet were on

173.

174

the ground. *Form follows function* was their way of life. Faith, simplicity, restraint, and honesty were their means, perfection their goal. In the secular world, the philosophy of the Bauhaus expressed similar views.

Both the Shakers' quest for perfection and their work ethic were shared by the Japanese, whose art and artifacts had, and still have, a profound influence on Western design, from bamboo objects to lacquerware, tools, tableware, machines, cameras, computers, automobiles, and video equipment, as well as to some of the great examples of the artisan's and architect's skills. Katsura Palace is the model of the spirit of *form follows function*.

One can be sure that form always follows ingenuity. But one cannot be sure that form always follows failure, or that the dictum is universally valid. We can't even be sure that the maxim *form follows function* is *always* valid. We can be sure that, with few exceptions, the solutions to functional problems are finite, whereas those to formal ones are infinite. The impulse to creation knows no exceptions — fashionable or practical. Cosmetics or jewelry, flatware or footware, hammers or nails — it is the urge to invent, to solve problems, visual or mechanical, that really matters.

More about the Grid

We all know how to use the grid.
Or do we?
To many, the grid triggers revolt.
It is a kind of repression — what today's
uninformed would deem archaic.

The grid is an elementary system
of organization, in harmony with the
classical concept of unity in variety.

The key to its proper application lies
not so much in varying the *size* of
individual squares or oblongs as in the
manner in which the content of these
squares is treated, oriented, multiplied,
scaled, enlarged, reduced, cropped,
manipulated, cut, mutilated, reversed,
exaggerated, overlapped, weighted,
shaded, blurred, isolated ...

Different from traditional design,
whether or not based on the grid system,
modern typography stresses
asymmetry and articulation of the total
page area.
Images are edge-oriented so that mar-
gins are relatively narrow.

These are not prescriptions; they are
working methods, visual ideas designed
to accomplish preconceived effects.
Their purpose is to treat commonplace
material imaginatively.
Variety and contrast are crucial goals.

I was born in Brooklyn.

It could have been Budapest, Buffalo, or Beijing, each with its own special ambience, each having its own aesthetic link to the cave paintings of Lascaux, irrespective of time, place, or distance.

At the Brooklyn Museum I got my first glimpse of the watercolors of John Singer Sargent, the etchings of Anders Zorn, the apples of Cézanne, and the icons and hieroglyphs of the great Egyptian collection, as well as the sculptures of Karl Milles that enliven most of the top floor of the museum. And one of its many galleries bears the name of Meyer Schapiro, the eminent art historian and teacher.

One could hear the highs of Galli-Curci and the lows of Chaliapin at the Brooklyn Academy of Music, stroll in the Brooklyn Botanic Garden as if it were Monet's Giverney, and visit Prospect Park, the haunt of serious Sunday painters and not-so-serious lovers.

Luna Park, Brooklyn's answer to Vienna's Prater and Copenhagen's Tivoli, was a treasure house not only of sights and sounds, of cotton candy and fun, but also of ideas about design. The beautiful horses that were anchored to a perpetually moving merry-go-round were a splendid lesson in the arts of ornamentation. The ferris wheels and fountains, water ballets and roller coasters, blinking signs and loud music were endless pleasures for the eye and ear.

The Brooklyn Bridge, an engineering feat more than an architectural wonder, led straight to the Woolworth Building, on the other side of the East River, whose fame lay in being the first skyscraper but whose aesthetic statement, at least in my view, never quite matched its height. The streets, tenements, shops, houses of

worship, houses of learning, and movie houses — with their lavish interiors and starlit ceilings — were also museums in which endless surprises and aesthetic experiences lay in wait for the curious wanderer.

On the map of this sprawling city was also the Brooklyn Paramount, which featured such celebrities as Rudy Vallee, with his theme song "My Time Is Your Time." And not too far away were the ear-splitting elevated trains that crisscrossed the city night and day. Department stores, worlds within a world, were among their busiest stops. In these stores one could shop or browse or learn about the wonders of the American dream. Occasionally, one could even savor the music of Mozart or Hoagy Carmichael. The train also stopped at the doorstep of my first art school, Pratt Institute. In each train slick paintings (car cards) of pretty Chesterfield cigarette girls stared down at every passenger. It may have been an unexpected prelude to my life class, but it was a questionable introduction to aesthetics.

One cannot leave out Ebbets Field, the home of the Brooklyn Dodgers, whose skillful pitching, catching, and hitting were thrilling performances. The place of hot dogs and cold beer was also the place where one could find grace and beauty. However, Ebbets Field was not too far from the slums in which poverty languished and Murder Incorporated flourished — but these were counterpoints.

Brooklyn, the city of "dees and dose," was also the city of thou and thine, of great composers, scientists, and poets; of George Gershwin, who wrote *Porgy and Bess*; of Richard Feynman, from nearby Far Rockaway, Queens, who calculated the mathematics of the atomic bomb; and of Walt Whitman, whose legacy, *Leaves of Grass*, left its imprint on the world of art. On March 31, 1851, having been invited to speak to a gathering at the Brooklyn Art Union, Whitman remarked, "To the artist has been given the command to go forth into all the world and preach the gospel of beauty [aesthetics]. The perfect man is the perfect artist."

Justin Kaplan,
Walt Whitman, A Life
(New York, 1980), 168

Select Bibliography

Barzun, Jacques	*The Use and Abuse of Art.* Washington, D.C.: National Gallery of Art, 1974
Beardsley, Monroe C.	*Aesthetics : Problems in the Philosophy of Criticism.* New York : Harcourt Brace, 1958
	Aesthetics from Classical Greece to the Present. New York : Macmillan, 1966
Bloom, Harold	*The Western Canon: The Books and School of the Ages.* New York: Harcourt Brace, 1994
Bosanquet, Bernard	*A History of Aesthetic.* New York : Humanities Press, 1966
Carritt, E. F.	*Philosophies of Beauty.* Westport : Greenwood Press, 1976
Collingwood, R.G.	*The Principles of Art.* New York : Oxford University Press, 1958
Cooper, David	*A Companion to Aesthetics.* Oxford: Blackwell, 1995
Croce, Benedetto	*Aesthetic.* Boston : David R. Godine, 1978
Delacroix, Eugène	*The Journal of Eugene Delacroix.* New York : Crown, 1948
Dewey, John	*Art as Experience.* New York : Minton Balch, 1934
Flew, Anthony	*A Dictionary of Philosophy.* New York : Macmillan, 1979
Fry, Roger	*Vision and Design.* New York : Oxford University Press, 1981
Gentile, Giovanni	*The Philosophy of Art.* Ithaca : Cornell University Press, 1972
Gilson, Etienne	*Painting and Reality.* Princeton : Princeton University Press, 1957
Goodman, Nelson	*Language of Art.* New York : Bobbs-Merrill, 1967
Graham, John D.	*System and Dialectics of Art.* New York : Delphic Studios, 1936
Greene, Theodore M.	*The Arts and the Art of Criticism.* Princeton : Princeton University Press, 1947
Greenough, Horatio	*Form and Function : Remarks on Art.* Berkeley : University of California Press, 1947
Harrison, C. / Wood, P.	*Art in Theory.* Oxford: Blackwell. 1993
Hegel, G.W. F.	*The Philosophy of Fine Arts.* New York : Gordon, 1976
Hildebrand, Adolf	*Das Problem der Form.* Strassburg : Heitz & Hendel, 1913
Hospers, John	*Introductory Readings in Aesthetics.* New York : Free Press, 1969
Howe, Irving	*Decline of the New.* New York : Harcourt, Brace and World, 1970
	The Idea of the Modern in Literature and the Arts. New York : Horizon, 1967
Huizinga, Johan	*Homo Ludens.* London : Maurice Temple Smith, 1970
Joad, Cyril E.	*Guide to Philosophy.* New York : Dover, 1936
Kallen, Horace	*Art and Freedom.* Westport : Greenwood Press, 1970
Kubler, George	*Studies in Ancient American and European Art.* New Haven : Yale University Press, 1985
Langer, Susanne	*Problems of Art : Ten Philosophical Lectures.* New York : Scribner's, 1957
Malraux, André	*Museum Without Walls.* Garden City : Doubleday, 1967
	The Voices of Silence. Princeton : Princeton University Press, 1978
Ogden, C. / Richards, I. A.	*The Meaning of Meaning.* New York : Harcourt Brace, 1956
Panofsky, Erwin	*Meaning in the Visual Arts.* Chicago : University of Chicago Press, 1982
Raphael, Max	*The Demands of Art.* Princeton : Princeton University Press, 1968
Richards, I. A.	*Principles of Literary Criticism.* London : Routledge & Kegan Paul, 1967
Rosenberg, Harold	*The De-definition of Art.* New York : Horizon, 1972
Schapiro, Meyer	*Theory and Philosophy of Art.* New York : Braziller, 1994
Sontag, Susan	*Against Interpretation and Other Essays.* New York : Anchor, 1990
Wallas, Graham	*The Art of Thought.* New York : Harcourt Brace, 1964
Wilson, Edmund	*Axel's Castle.* New York : Scribner's, 1943
Wölfflin, Heinrich	*The Art of the Italian Renaissance.* New York : Schocken, 1963
	Principles of Art History. New York : Dover, 1950
	Renaissance and Baroque. Ithaca : Cornell University Press, 1966
	The Sense of Form in Art. New York : Chelsea, 1958
Worringer, Wilhelm	*Abstraction and Empathy.* New York : Meridian, 1967
	Form in Gothic. London : Putnam, 1927
Zweig, Arnulf	*The Essential Kant.* New York : New American Library, 1970

Apollinaire, G. *Apollinaire on Art : Essays and Reviews. 1902-1918.* New York : Viking, 1972
Apollonio, Umbro *Futurist Manifestos.* London : Thames and Hudson, 1973
Barr, Alfred *Cubism and Abstract Art.* New York : Museum of Modern Art, 1966
Baudelaire, Charles *The Mirror of Art.* London : Phaidon, 1955
Bell, Clive *Art.* London : Chatto and Windus, 1949
Bradbury, M. / McFarlene, J. *Modernism, 1890-1930.* New York : Penguin, 1976
Chipp, H. B. *Theories of Modern Art.* Berkeley : University of California Press, 1968
Cooper, Douglas *The Cubist Epoch.* Los Angeles : Phaidon, 1971
Frascina, F. / Harrison, C. *Modern Art and Modernism.* New York : Harper and Row, 1983
Foucault, Michel *This Is Not a Pipe.* Berkeley : University of California Press, 1982
Gablik, Suzi *Progress in Art.* New York : Rizzoli, 1977
Golding, John *Visions of the Modern.* London : Thames and Hudson, 1994
Gray, Camilla *The Great Experiment : Russian Art. 1863-1922.* New York : Abrams, 1971
Hamilton, George H. *19th and 20th Century Art.* Englewood Cliffs : Prentice Hall, 1971
Hauser, Arnold *The Social History of Art.* New York : Knopf, 1952
Herbert, Robert L. *Modern Artists on Art : Ten Unabridged Essays.* Englewood Cliffs : Prentice Hall, 1964
Jaffe, Hans L. C. *De Stijl : 1917-1931.* Cambridge : Belknap Press, 1986
Johnson, Ellen H. *Modern Art and the Object.* New York : Harper and Row, 1976
Johnson, Paul *Modern Times.* New York : Harper and Row, 1983
Kandinsky, W. / Marc, F. *The Dada Painters and Poets.* New York : Wittenborn, 1945
Kozloff, Max *Dadaism and Futurism.* New York : Charterhouse, 1973
Lehmann, A. G. *The Symbolist Aesthetic in France. 1885-1895.* Oxford : Blackwell, 1968
Lindinger, Herbert *Ulm, Hochschule für gestaltung. Ulm Design : The Morality of Objects.* Cambridge : MIT Press, 1991
MacLeod, Glen *Wallace Stevens and Modern Art.* New Haven : Yale University Press, 1993
Motherwell, Robert *The Dada Painters and Poets.* Cambridge : Harvard University Press, 1989
Ozenfant, Amedée *Foundations of Modern Art.* New York : Dover, 1952
Rewald, John *The History of Impressionism.* New York : Museum of Modern Art, 1973
 Post-Impressionism. New York : Museum of Modern Art, 1978
Richardson, A. / Stangos, N. *Concepts of Modern Art.* Baltimore : Penguin, 1974
Rowland, Kurt *A History of the Modern Movement.* New York : Van Nostrand Reinhold, 1973
Schapiro, Meyer *Modern Art, 19th and 20th Century.* New York : Braziller, 1994
 Nature of Abstract Art. New York : American Marxist Association, 1937
Schweiger, Werner J. *Wiener Werkstaette, Design in Vienna.* New York : Abbeville, 1984
Shattuck, Roger *The Banquet Years.* New York : Vintage, 1968
Tashjian, Dickran *Skyscraper Primitives.* Middletown : Wesleyan University Press, 1975
Wallis, Brian *Art after Modernism.* New York : New Museum of Contemporary Art, 1984
Wingler, Hans M. *The Bauhaus : Weimar, Dessau, Berlin, Chicago.* Cambridge : MIT Press, 1978

Ball, Johnson	*William Caslon : 1693-1766.* Kineton: Roundwood, 1973
Bennett, Paul A.	*Postscripts on Dwiggins. Essays and Recollections.* New York: Typophiles, 1960
Crane, Walter	*Line and Form.* London: George Bell & Sons, 1902
Davenport, P./Thompson, P.	*Visual Language.* London: Bergstrom and Boyle, 1980
De Vinne, Theodore	*Practice of Typography : Correct Composition.* New York: Oswald, 1921
Dwiggins, William A.	*Layout in Advertising.* New York: Harper, 1948
Eicher, Ottl	*Typographie.* Ulm: Ernst & Sohn, 1988
Gersner, K./Kutter, M.	*The New Graphic Design.* Basel: Niggli, 1959
Gill, Eric	*An Essay on Typography.* Boston: David R. Godine, 1989
Glaser, Milton	*Graphic Design.* New York: Overlook, 1990
Heller, Steven	*Seymour Chwast, The Left-Handed Designer.* New York: Abrams, 1985
Hofmann, Armin	*Graphic Design Manual.* New York: Van Nostrand Reinhold, 1977
Hollister, Paul	*American Alphabets.* New York: Harper and Bros., 1930
Hostettler, Rudolf	*The Printer's Terms.* St. Gallen Verlag, Zollikofer, 1949
Jeker, Werner	*Graphic Design.* Lausanne: Musée des arts décoratifs, 1992
Johnston, Edward	*Writing and Illuminating and Lettering.* London: Pitman, 1932
Kauffer, E. McKnight	*The Art of the Poster.* London: Cecil Palmer, 1924
Loesch, Uwe	*The Place, the Times, and the Point.* Frankfort am Main: Museum für Kunsthandwerk, 1991
Lois, George	*The Art of Advertising.* New York: Abrams, 1977
MacCarthy, Fiona	*Eric Gill.* London: Faber and Faber, 1989
	William Morris. London: Faber and Faber, 1994
McLean, Ruari	*Typographers on Type.* London: Lund Humphries, 1995
Mari, Enzo	*The Function of Esthetic Research.* Milan: Edizioni de Comunita, 1970
Meggs, Philip	*A History of Graphic Design.* New York: Van Nostrand Reinhold, 1983
Mendell, Pierre	*Graphic Design, Mendell & Oberer.* Boston: Birkhauser, 1987
Morison, Stanley	*Letterforms. Typographic and Scriptorial.* New York: Typophiles, 1968
	On Type Design : Past and Present. London: E. Benn, 1962
Mouron, Henri	*A. M. Cassandre.* New York: Rizzoli, 1985
Müller-Brockmann, Joseph	*The Graphic Designer and His Design Problems.* New York: Hastings House, 1983
Odermatt, S./Tissi, R.	*Graphic Design.* Zurich: Waser Verlag, 1993
Pirovano, Carlo	*Max Huber.* Milan: Electa, 1982
Rambow, Gunther	*Images sans paroles.* Chaumont: Bibliothèque Municipal de Chaumont, 1991
Rand, Paul	*Advertisement : Ad Vivum, Ad Hominum?* Daedalus, Winter, 1960
	Design, Form, and Chaos. New Haven: Yale University Press, 1993
	A Designer's Art. New Haven: Yale University Press, 1985
	Thoughts on Design. New York: Wittenborn, 1936. London: Studio Vista, 1970
	The Trademarks of Paul Rand. New York: Wittenborn, 1960
Renner, Paul	*Die Kunst der Typographie.* Berlin: Frenzel and Englebrecher, 1939
Ross, Denman W.	*A Theory of Pure Design.* New York Peter Smith, 1933
Ruder, Emil	*Typography.* New York: Hastings House, 1981
Ruegg, Ruedi	*Basic Typography : Design with Letters.* New York: Van Nostrand Reinhold, 1989
Stankowski, Anton	*Visuelle Kommunikation : Ein Design-Handbuch.* Berlin: Reimer, 1994
Tanchis, Aldo	*Bruno Munari : Design as Art.* Cambridge: MIT Press, 1987
Tschichold, Jan	*Designing Books.* New York: Wittenborn, 1950
	The New Typography. Berkeley: University of California Press, 1996
	Treasury of Alphabets and Lettering. New York: Design Press, 1992
Updike, Daniel B.	*Printing Types.* Cambridge: Harvard University Press, 1937
Vignelli, Massimo	*Design.* New York: Rizzoli, 1981
Weingart, Wolfgang	*Typographer and Designer.* Baden: Princeton Architectural Press, 1996
Wieczorek, Stanislaw	*Henryk Tomaszewski.* Warsaw: Akademia Sztuk Pieknych, 1993
Zapf, Hermann	*Ein Arbeitsbericht.* Hamburg: Maximilian Gesellschaft, 1984

Abbott, Edwin A.	*Flatland. A Romance of Many Dimensions.* New York: Dover, 1992
Arnheim, Rudolf	*Art and Visual Perception.* Berkeley: University of California Press, 1974
	Entropy & Art. Berkeley: University of California Press, 1971
	New Essays on the Psychology of Art. Berkeley: University of California Press, 1986
	The Power of the Center. Berkeley: University of California Press, 1988
	Toward a Psychology of Art. Berkeley: University of California Press, 1966
	Visual Thinking. Berkeley: University of California Press, 1980
Barnes, Albert C.	*The Art in Painting.* New York: Harcourt Brace, 1928
Barzun, Jacques	*Begin Here.* Chicago: University of Chicago Press, 1991
	A Stroll with William James. Chicago: University of Chicago Press, 1984
Bell, Daniel	*Cultural Contradictions of Capitalism.* New York: Basic, 1978
Bolinger, D. / Sears, D. A.	*Aspects of Language.* Fort Worth: College Publications, 1981
Bragdon, Claude	*The Beautiful Necessity.* New York: Knopf, 1927
Ewen, Stuart	*All Consuming Images.* New York: Basic, 1990
Forty, Adrian	*Objects of Desire : Design and Society.* New York: Thames and Hudson, 1992
Gregory, Richard L.	*Eye and Brain : The Psychology of Seeing.* Princeton: Princeton University Press, 1990
	The Intelligent Eye. New York: McGraw-Hill, 1970
Himmelfarb, Gertrude	*On Looking into the Abyss.* New York: Oxford University Press, 1993
Hughes, Robert	*Culture of Complaint.* New York: Oxford University Press, 1993
	Nothing if Not Critical. New York: Viking Penguin, 1992
James, Henry	*The Painter's Eye.* Madision: University of Wisconsin Press, 1989
James, William	*Pragmatism and the Meaning of Truth.* Cambridge: Harvard University Press, 1978
Kimball, Roger	*Tenured Radicals.* New York: Harper Collins, 1991
Koffka, Franz	*Gestalt Psychology.* New York: Harcourt Brace, 1935
Kouwenhoven, John A.	*Beer Can by the Highway.* Baltimore: Johns Hopkins University Press, 1988
	Made in America. New York: Norton, 1948
Kramer, Hilton	*The Age of the Avant-Garde.* New York: Farrar, Straus, and Giroux, 1973
Lehman, David	*Signs of the Times.* New York: Poseidon, 1992
McKibben, Bill	*The Age of Missing Information.* New York: Random House, 1992
Okakura, Kakuzo	*The Book of Tea.* Boston: Shambala, 1993
Petroski, Henry	*The Evolution of Useful Things.* New York: Knopf, 1992
	The Pencil. New York: Knopf, 1992
Postman, Neil	*Amusing Ourselves to Death.* New York: Viking Penguin, 1986
	The Disappearance of Childhood. New York: Delacorte, 1982
	Technopoly : The Surrender of Culture to Technology. New York: Random House, 1993
Richards, I. A.	*Design for Escape.* New York: Harcort, Brace, and World, 1968
Roth, Dieter	*246 Little Clouds.* New York: Something Else Press, 1968
Spencer, Harold	*Readings in Art History.* New York: Scribner's, 1982
Strunk, W. Jr. / White, E. B.	*Elements of Style.* New York: Macmillan, 1979
Wertheimer, Max	*Productive Thinking.* New York: Harper, 1945
Wittkower, Rudolf	*Architectural Principles in the Age of Humanism.* New York: St. Martin's, 1988
	Born Under Saturn. New York: Norton, 1963
	The Divine Michelangelo. London: Phaidon, 1964
	Gothic Versus Classic. New York: Braziller, 1974
	Idea and Image : Studies in Italian Rennaisance. London: Thames and Hudson, 1978
	Palladio and Palladionism. New York: Braziller, 1974
Zinsser, William	*On Writing Well.* New York: Harper, 1994

Badt, Karl	*The Art of Cézanne.* New York: Hacker Art Books, 1985
Baljeu, Joost	*Theo Van Doesburg.* New York: Macmillan, 1974
Boesiger, W.	*Le Corbusier: Oeuvre Complète.* New York: Rizzoli, 1992
Cabanne, Pierre	*Dialogues with Marcel Duchamp.* New York: DaCapo, 1987
Cork, Richard	*David Bomberg.* New Haven: Yale University Press, 1987
Franzke, Andreas	*Dubuffet.* Kolin: Dumont, 1990
Fry, Roger	*Cézanne: A Study of His Development.* Chicago: University of Chicago Press, 1989
Gablik, Suzi	*Magritte.* New York: Thames and Hudson, 1985
Gilot, F. / Lake, C.	*Life with Picasso.* New York: Doubleday, 1989
Grundberg, Andy	*Brodovitch.* Bergenfield: Abrams, 1989
Huyghe, René	*Gauguin.* New York: Crown, 1988
Jencks, Charles	*Le Corbusier and the Tragic View of Architecture.* London: Penguin, 1987
Kahnweiler, Daniel	*Juan Gris.* New York: Abrams, 1969
Kandinsky, Wassily	*Point and Line to Plane.* New York: Dover, 1979
Klee, Paul	*The Paul Klee Notebooks, Vol 2 · The Nature of Nature.* New York: Overlook, 1992
Léger, Fernand	*Functions of Painting.* New York: Viking, 1973
Lissitzky-Kuppers, Sophie	*El Lissitzky.* New York: Thames and Hudson, 1980
Loren, Erle	*Cézanne's Compositions.* Berkeley: University of California, 1963
MacCarthy, Fiona	*William Morris.* London: Faber and Faber, 1994
Malevich, Kasimir	*Essays on Art,* 3 vols. Copenhagen: Borgen, 1968
	The Non-Objective World. Chicago: Theobald, Paul, 1959
Marinetti, Filippo Tommaso	*Selected Writings.* New York: Farrar, Straus, and Giroux, 1972
Millan, Gordon	*A Throw of the Dice: Life of Stephane Mallarmé.* London: Secker and Warburg, 1994
Reff, Theodore	*Degas, The Artist's Mind.* New York: Metropolitan Museum of Art, 1976
Rewald, John	*Cézanne: A Biography.* New York: Abrams, 1990
	Cézanne Letters. New York: Hacker Art Books, 1985
Rubin, William	*Picasso in the Collection of the Museum of Modern Art.* New York: MOMA, 1972
Schmalenbach, Werner	*Kurt Schwitters.* New York: Abrams, 1967
Schulze, Franz	*Mies van der Rohe: A Critical Biography.* Chicago: University of Chicago Press, 1989
Seuphor, Michel	*Mondrian.* New York: Abrams, 1956
Spies, Werner	*Max Ernst, Loplop.* New York: Braziller, 1983
Thompson, Edward P.	*William Morris: Romantic to Revolutionary.* New York: Pantheon, 1977
Torczyner, Harry	*Magritte: Ideas and Images.* New York: Abrams, 1977
Van Doesburg, Theodore	*Principles of Neo-Plastic Art.* Greenwich: New York Graphic Society, 1968
Van Gogh, Vincent	*Van Gogh Letters.* New York: New York Graphic Society, 1959
Vitali, Lamberto	*Giorgio Morandi.* Milan: Edizione Del Milione, 1964
Westbrook, Robert B.	*John Dewey and American Democracy.* Ithaca: Cornell University Press, 1991
Zola, Emile	*The Masterpiece.* New York: Oxford University Press, 1993

Architecture

Alexander, Christopher	*Notes on the Synthesis of Form.* Cambridge: Harvard University Press, 1964
Arnheim, Rudolf	*The Dynamics of Architectural Form.* Berkeley: University of California Press, 1977
Gravagnuolo, Benedetto	*Adolf Loos: Theory and Works.* New York: Rizzoli, 1982
Le Corbusier	*The City of Tomorrow and Its Planning.* New York: Dover, 1987
	The Modulor 1 and Modulor 2. Cambridge: Harvard University Press, 1980
	Towards a New Architecture. New York: Dover, 1986
Morse, Edward S.	*Japanese Homes and Their Surroundings.* Boston: Ticknor, 1886
Naito, Akira	*Katsura, A Princely Retreat.* New York: Harper and Row, 1977
Rocheleau, P. / Sprigg, J.	*Shaker Built.* New York: Monacelli, 1994
Taut, Bruno	*Houses and People of Japan.* Tokyo: Sanseido, 1937

186.

Banham, R.	*Theory and Design in the First Machine Age.* Cambridge: MIT Press, 1980
Giedion, Sigfried	*Space, Time, and Architecture.* Cambridge: Harvard University Press, 1967
Gombrich, E. H.	*The Image and the Eye.* Ithaca: Cornell University Press, 1982
	In Search of Cultural History. Oxford: Clarendon, 1969
	Meditations on a Hobby Horse. London: Phaidon, 1985
	The Sense of Order. Ithaca: Cornell University Press, 1979
	Tributes: Interpreters of Our Cultural Tradition. Ithaca: Cornell University Press, 1984
Kepes, Gyorgy	*The Language of Vision.* Chicago: Theobald, 1959
Kranz, Kurt	*Art: The Revealing Experience.* New York: Shorewood, 1964
Moholy-Nagy, Laszlo	*The New Vision.* New York: Norton, 1938
	Vision in Motion. Chicago: Theobald, Paul, 1947
Mumford, Lewis	*Technics and Civilization.* San Diego: Harcourt, Brace, and World, 1963
Papanek, Victor	*Design for the Real World.* Chicago: Academy of Chicago Publishers, 1985

Geometry and Design

Bouleau, Charles	*The Painter's Secret Geometry.* New York: Harcourt, Brace, and World, 1963
Borissavlievitch, Miloutine	*The Golden Number.* New York: Philosophical Library, 1958
Bunim, Miriam Schild	*Space in Medieval Painting.* New York: AMS Press, 1940
Ghyka, Matela	*The Geometry of Art and Life.* New York: Dover, 1978
Ivins, William M.	*Art & Geometry.* New York: Dover, 1964
Scholfield, P. H.	*The Theory of Proportion in Architecture.* Cambridge: Cambridge University Press, 1958
Vitruvius	*The Ten Books on Architecture.* New York: Dover, 1960
Weyl, Herman	*Symmetry.* Princeton: Princeton University Press, 1952
Wittkower, Rudolf	*Systems of Proportion.* Architectural Yearbook 5, 1959

Film

Arnheim, Rudolf	*Film as Art.* Berkeley: University of California Press, 1957
Eisenstein, Sergei	*Film Essays, with a Lecture.* Princeton: Princeton University Press, 1981
	Film Form: Essays in Film Theory. New York: Meridian, 1957
	The Film Sense. New York: Harcourt, Brace, and World, 1947

DATE DUE

The Library Store #47-0106